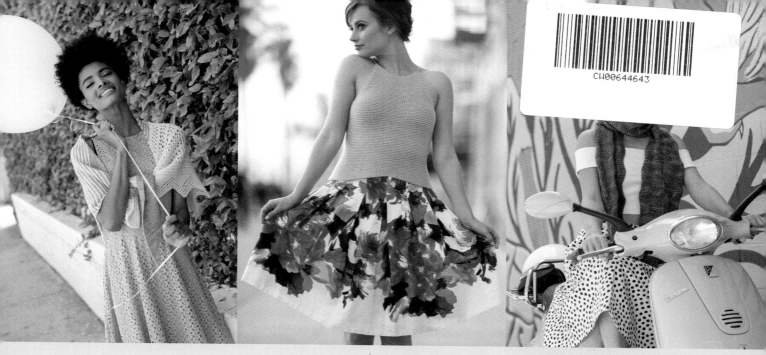

garter stitch REVIVAL

20 creative knitting patterns featuring the simplest stitch

CURATED BY KERRY BOGERT

INTERWEAVE
interweave.com

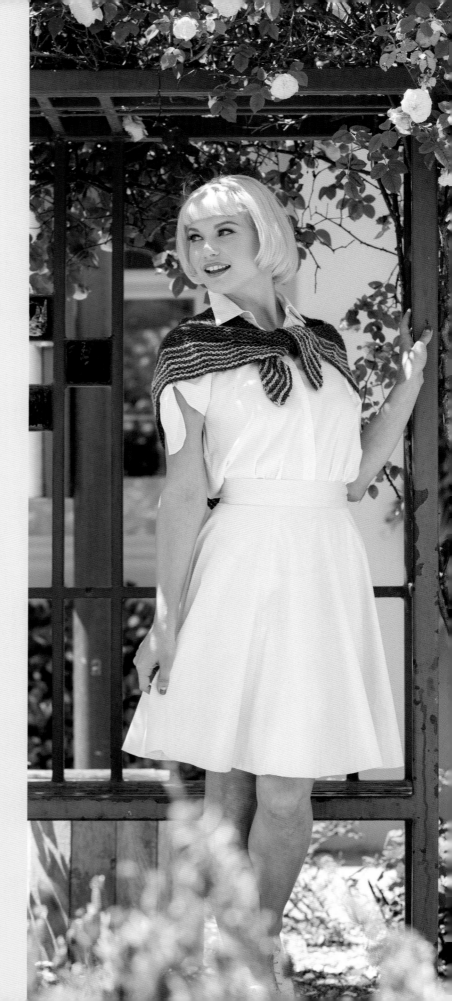

fw
a content + ecommerce company

www.fwcommunity.com

20 19 18 17 16 5 4 3 2 1

Distributed in Canada by Fraser Direct
100 Armstrong Avenue
Georgetown, ON, Canada L7G 5S4
Tel: (905) 877-4411

Distributed in the U.K. and Europe
by F&W MEDIA INTERNATIONAL
Brunel House, Newton Abbot, Devon
TQ12 4PU, England
Tel: (+44) 1626 323200
Fax: (+44) 1626 323319
E-mail: enquiries@fwmedia.com

SRN: 17KN01
ISBN-13: 978-1-63250-298-8

Editors: Kerry Bogert and Leslie T. O'Neill
Technical Editor: Larissa Gibson
Cover Designer: Charlene Tiedeman
Interior Designer: Erin Dawson
Illustrator: Kathie Kelleher
Photographer: Harper Point Photography

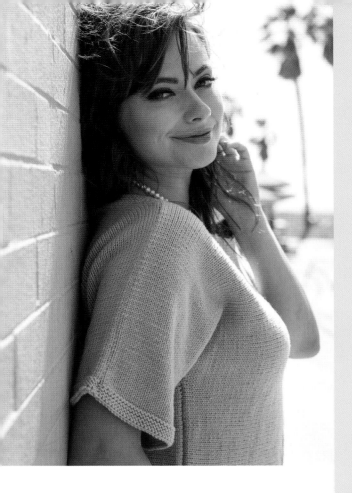

CONTENTS

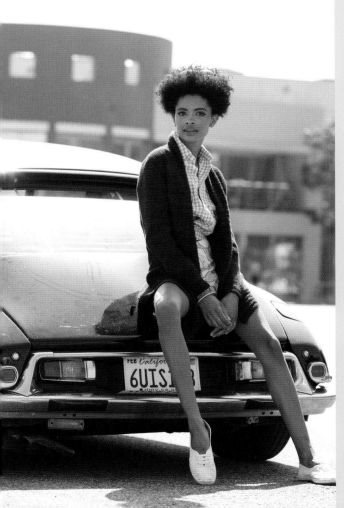

Foreword

BY HOLLI YEOH

Garter stitch is the first stitch pattern we learn as knitters. As a novice, I was eager to learn new stitches and quickly discarded garter stitch; I thought it was a little too rustic for my taste. I much preferred the smooth surface of stockinette stitch, which I felt was more polished and refined.

As an experienced knitter and designer, I now see the beauty and sophistication in garter stitch. I've enjoyed revisiting it for its texture and mathematical genius. I'll often use it to quietly offset other stitch patterns. It is beautifully humble and would never outshine the featured act.

When I use garter stitch as the main star in a design, it's not brash or bold. The modest garter stitch simply lets its texture and lovely repetition sing out and take center stage.

I have enjoyed embracing garter stitch and marvel now at its simplicity, a simplicity belied by its ability to create stunning designs.

In this book, you, too, will discover the beauty of garter stitch. These designs will give you the pleasure of creating beautiful things with the simplest of stitches.

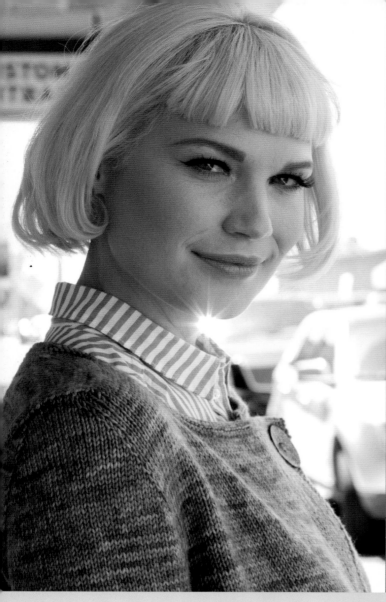
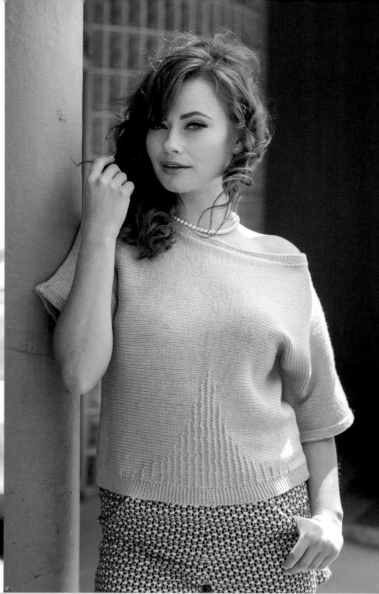

CHAPTER ONE

garter stitch details

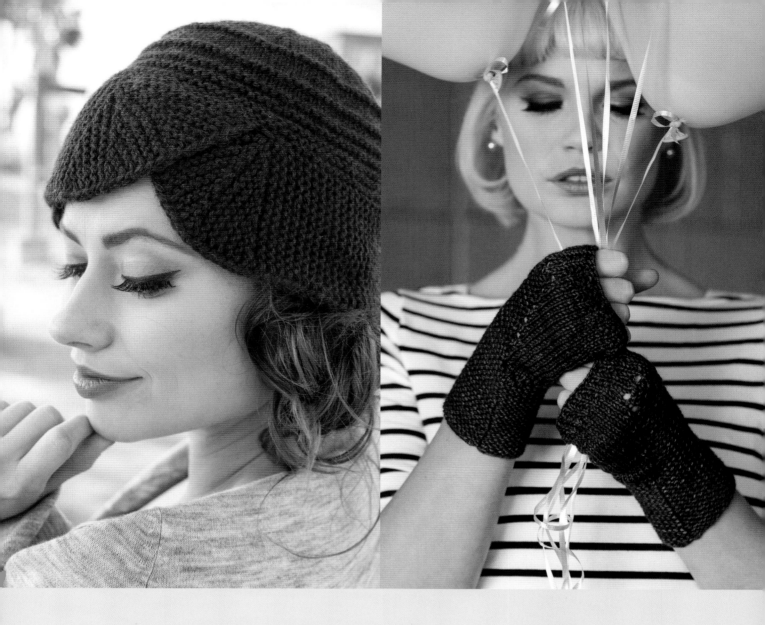

Garter stitch provides just the right accent for any type of project. It creates a fabric that lies flat, so it's perfect for hems and cuffs, as in Kristen TenDyke's Just Peachy Saddle Shoulder Cardigan. A small amount of garter stitch adds visual interest while maintaining clean lines, as in Toby Roxane Barna's Asymmetrical Cropped Jacket. It even makes a striking design element, as in Megan Elyse William's Flapper Cloche.

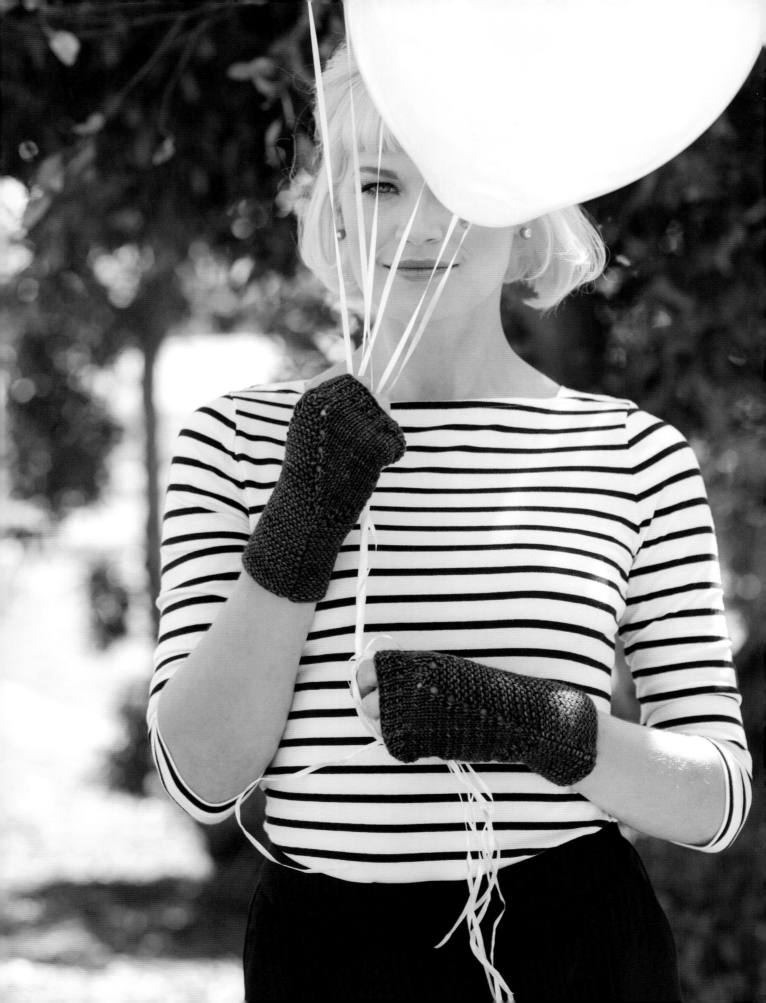

Be True Fingerless Mitts

DESIGNED BY JENNIE SANTOPIETRO

These playful mitts are knit in the round, beginning with a cozy garter stitch cuff that is whittled down to a pair of arrows worked on the back of the hand and on the palm. No matter which size you choose, these easy mitts are so quick to knit, you'll want to make a pair for every guy and gal on your gift list.

FINISHED SIZE

To fit sizes Adult Woman (Adult Man).
7½ (8)" (19 [20.5] cm) hand circumference and 7½ (8¾)" (19 [22] cm) long.

YARN

DK weight (#3 Light).
Shown here: SweetGeorgia Yarns Superwash DK (100% superwash merino wool; 256 yd [234 m]/ 4 oz [115 g]): Deep Cove, 1 skein (Adult Woman)
Not shown: SweetGeorgia Yarns Superwash DK (100% superwash merino wool; 256 yd [234 m]/ 4 oz [115 g]: Charcoal, 1 skein (Adult Man).

NEEDLES

Size U.S. 6 (4 mm): set of 4 or 5 double-pointed (dpn).
Adjust needle size if necessary to obtain the correct gauge.

NOTIONS

Marker (m); tapestry needle; stitch holder.

GAUGE

20 sts and 34 rows = 4" (10 cm) in garter st in the rnd, blocked.

Notes

* Stitches to the right of the red line on the charts are on the front needle(s). Stitches to the left of the red line are on the back needle(s). It is helpful to adjust stitches as indicated by the red line so that the newly CO stitches aren't pulled out of shape. You do not need to place a marker at the beginning of the round; use your CO tail as a guide.

* It may be helpful to mark the center thumb gusset stitch to guide the placement of the increases.

STITCH GUIDE

Broken Rib Pattern (even number of sts)

RND 1: *K1, p1; rep from * to end of rnd.

RND 2: Knit.

Rep Rnds 1–2 for Broken Rib Pattern.

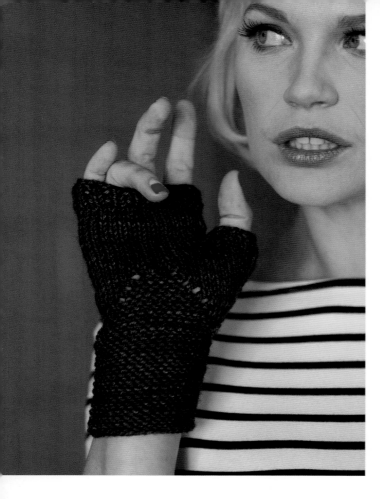

Work through Rnd 41 (47) of chart.

BO all sts in patt.

Thumb

Return 15 held thumb sts to needles and rejoin yarn, pick up and knit (see Glossary) 3 sts in thumb gap CO, join for working in the rnd—18 sts.

Work 6 rnds in Broken Rib Pattern (see Stitch Guide).

Knit 1 rnd.

BO all sts in patt.

RIGHT MITT

Cuff

Work as for Left Mitt until piece measures 2¾" (3") (7 [7.5] cm).

Hand

Work Rnds 1–21 (25) of Women's (Men's) Right Mitt chart.

RND 22 (26): Work to thumb gusset, transfer 15 thumb sts to holder, use the backward-loop method to CO 3 sts over thumb gap, work to end of rnd—36 (40) sts.

Work through Rnd 41 (47) of chart.

BO all sts in patt.

Thumb

Work as for left thumb.

FINISHING

Weave in ends, closing any gaps in the thumb with the yarn tails. Block to measurements.

LEFT MITT

Cuff

Using the long-tail method (see Glossary), CO 34 (38) sts, join for working in the rnd, being careful not to twist sts.

Beg with a purl rnd, work garter st in the rnd (knit 1 rnd; purl 1 rnd) until piece measures 2¾" (3") (7 [7.5] cm) from CO.

Hand

Work Rnds 1–21 (25) of Women's (Men's) Left Mitt chart.

RND 22 (26): Work to thumb gusset, transfer 15 thumb sts to holder, use the backward-loop method (see Glossary) to CO 3 sts over thumb gap, work to end of rnd—36 (40) sts.

MEN'S LEFT MITT CHART

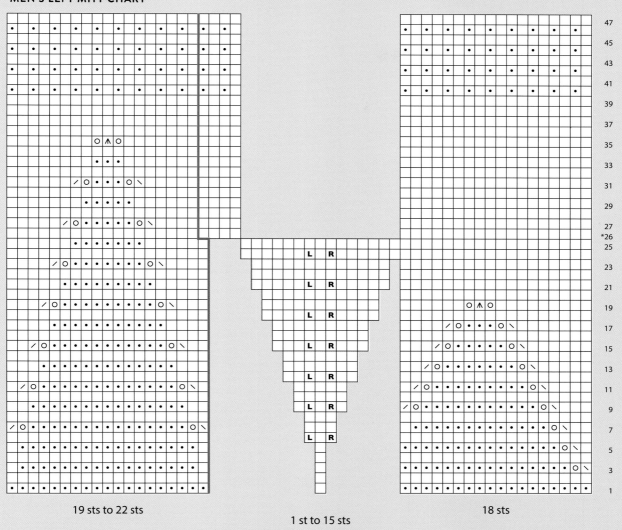

19 sts to 22 sts

1 st to 15 sts

18 sts

	knit		**L**	M1L (see Glossary)
•	purl		**R**	M1R (see Glossary)
O	yo		**∧**	s2kp2 (see Glossary)
╱	k2tog		┃	recommended division for front and back needles (see Notes)
╲	ssk			

*** Work as given in instructions**

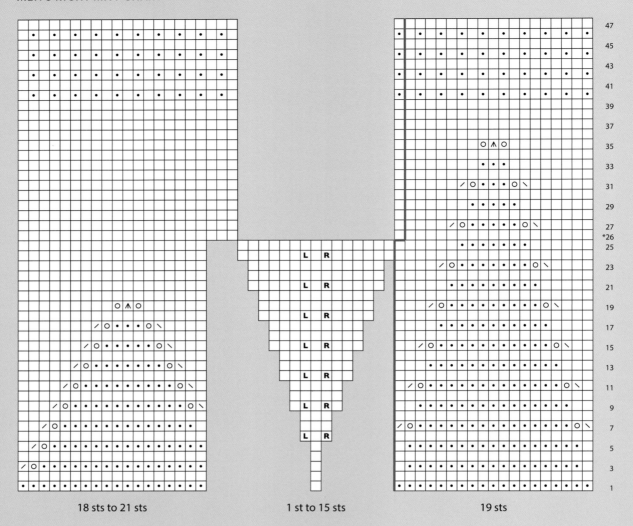

18 sts to 21 sts 1 st to 15 sts 19 sts

	knit		**L**	M1L (see Glossary)
•	purl		**R**	M1R (see Glossary)
○	yo		**⋀**	s2kp2 (see Glossary)
╱	k2tog			recommended division for front and back needles (see Notes)
╲	ssk			***Work as given in instructions**

WOMEN'S RIGHT MITT CHART

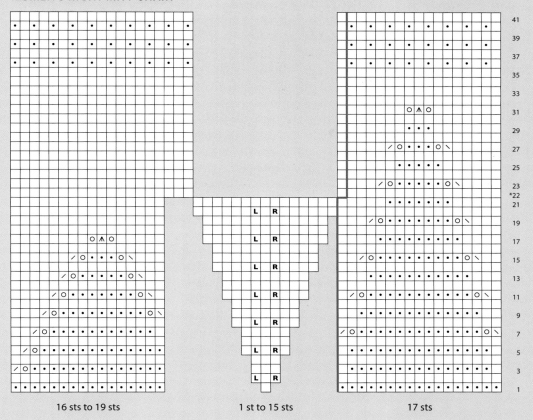

16 sts to 19 sts 1 st to 15 sts 17 sts

WOMEN'S LEFT MITT CHART

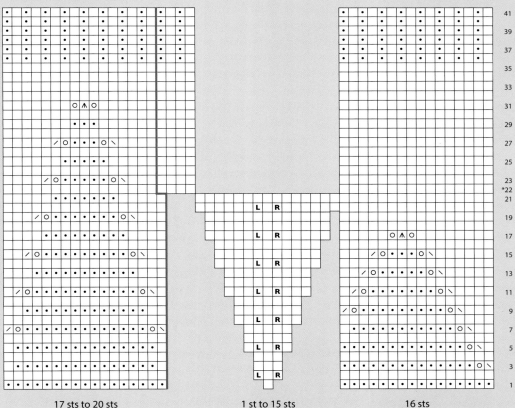

17 sts to 20 sts 1 st to 15 sts 16 sts

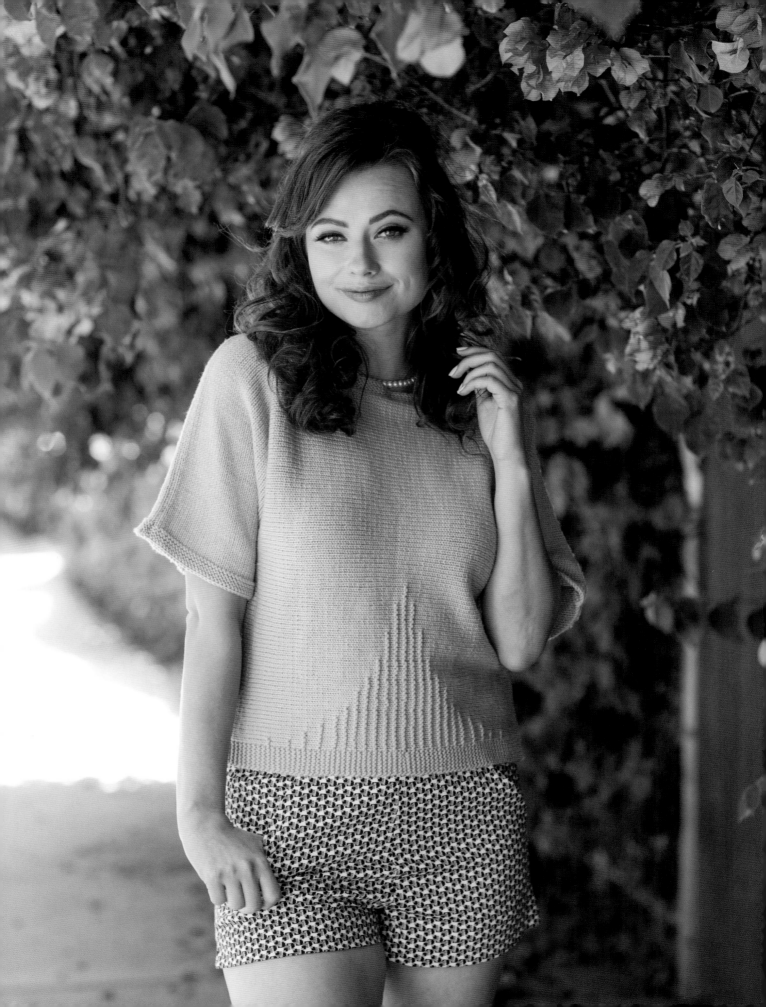

Seashell Dolman Tee

DESIGNED BY KIRI FITZGERALD-HILLIER

Knit in a delicate shell pink and featuring dolman sleeves, this simple, effortless top will become a warm-weather wardrobe staple. It's worked from cuff to cuff in stockinette and features a subtle crest pattern. Slim garter stitch cuffs and waistband provide a crisp finish.

FINISHED SIZE

35 (38, 39, 41, 44, 46, 48)" (89 [96.5, 99, 104, 112, 117, 122] cm) bust circumference.

Tee shown measures 38" (96.5 cm).

YARN

DK weight (#3 Light).

Shown here: Debbie Bliss Rialto DK (100% extra-fine superwash merino wool; 114 yd [105 m]/ 1¾ oz [50 g]): #66 Vintage Pink, 8 (9, 9, 10, 10, 11, 11) balls.

NEEDLES

Size U.S. 6 (4 mm): straight.
Size U.S. 5 (3.75 mm): straight.
Size U.S. 5 (3.75 mm): 16" (40 cm) circular needle (cir).
Adjust needle sizes if necessary to obtain the correct gauge.

NOTIONS

Size F/5 (3.75 mm) crochet hook; markers (m); tapestry needle.

GAUGE

20 sts and 32 rows = 4" (10 cm) in stockinette st using larger needles, blocked.

Notes

* This tee is worked flat from side to side in two pieces, front and back, beginning and ending at the cuffs.
* A chain-edge CO (see Glossary) is used to create a clean edge that mimics a standard bind-off.

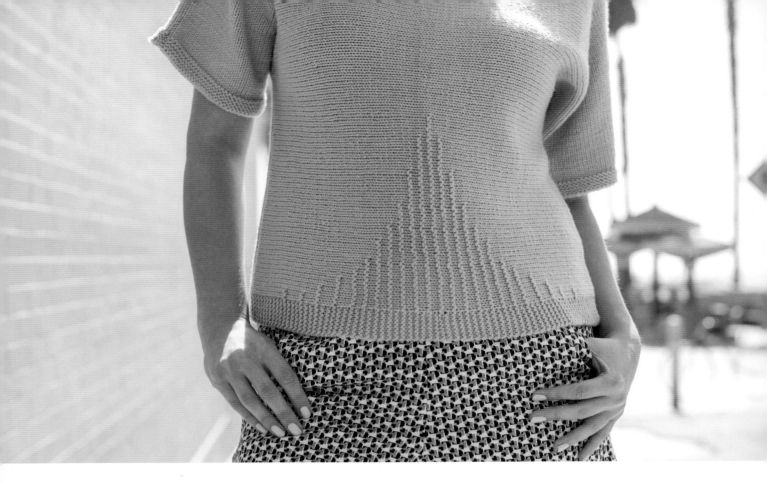

STITCH GUIDE

Crest Pattern

ROW 1 AND ALL RS ROWS: (RS) Knit.

ROW 2: (WS) K9, place marker (pm), [p2, pm] 4 times, p4, pm, p3, pm, p4, pm, p5, pm, p7, pm, p4, pm, purl to end of row.

ROWS 4, 6, AND 8: K7, purl to end of row.

ROW 10: Knit to first m, remove m, purl to end of row.

ROWS 11–28: Rep Rows 5–10 three times.

ROWS 29–56: Rep Rows 7–10 seven times.

ROW 58: K7, [p2, pm] 5 times, p4, pm, p3, pm, p4, pm, p5, pm, p7, pm, purl to end of row.

ROW 60: Knit to last m, remove m, purl to end of row.

ROW 62: K7, purl to end of row.

ROWS 64–83: Rep Rows 60–63 five times.

ROW 84: Rep Row 60.

ROWS 86 AND 88: K7, purl to end of row.

ROW 90–107: Rep Rows 84–89 three times.

ROW 108: K7, purl to end of row.

ROW 110: K9, purl to end of row.

TOE

With needle 1, CO on 8 (8, 10) sts.

Knit 4 (8, 8) rows garter st (knit every row).

NEXT ROW: K8 (8, 10), with needle 2 pick up and knit 2 (4, 4) sts along left edge, with needle 3 pick up and knit 8 (8, 10) sts along CO edge, with needle 4 pick up and knit 2 (4, 4) sts along right edge—20 (24, 28) sts.

Rearrange sts over dpn as foll:

Slip 1 (2, 2) sts from needle 4 onto needle 1; this will be the beg of the rnd.

Slip 1 (2, 2) rem sts from needle 4 onto needle 3.

Work sts onto needles 1–4 as foll:

SET-UP RND: Needle 1: slip (sl) 1 (2, 2) sts, p4 (4, 5); needle 2: purl to end of needle, p1 (2, 2) from next needle; needle 3: purl to end of needle, p4 (4, 5) from next needle; needle 4: purl to end of needle—5 (6, 7) sts on each needle.

INC RND: Needle 1: K1, M1R (see Glossary), knit to end of needle; needle 2: knit to last st, M1L (see Glossary), k1; needle 3: K1, M1R , knit to end of needle; needle 4: knit to last st, M1L, k1—4 sts inc'd.

NEXT RND: Purl.

Rep last 2 rnds 9 more times 60 (64, 68) sts total—15 (16, 17) sts on each needle.

FOOT

Work in St st (knit every rnd) until piece measures 2½ (3½, 4½)" (6.5 [9, 11.5] cm) from CO.

NEXT RND: Needles 1 and 2: K1 (2, 3), work Argyle chart over 28 sts, k1 (2, 3); needles 3 and 4: knit to end of rnd.

Rep last rnd, working through Rnd 45 of chart.

RND 46: Needles 1 and 2: K1 (2, 3), work Rnd 46 of Argyle chart over 28 sts, k1 (2, 3); needles 3 and 4: drop working yarn, and with waste yarn, knit to end of rnd, drop waste yarn, return to beg of needle 3, and with working yarn, knit to end of rnd.

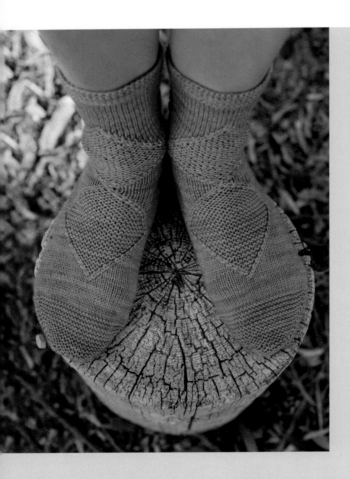

ARGYLE CHART

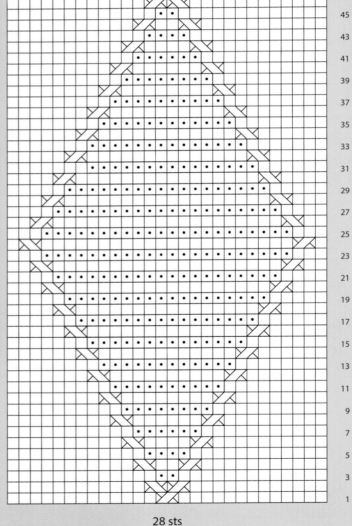

45
43
41
39
37
35
33
31
29
27
25
23
21
19
17
15
13
11
9
7
5
3
1

28 sts

	knit
•	purl
	1/1 RC (see Stitch Guide)
	1/1 LC (see Stitch Guide)

LEG

Cont in patt and rep Rnds 1–13 of Argyle chart.

NEXT RND: Needles 1 and 2: K1 (2, 3), work Rnd 14 of Argyle chart over 28 sts, k1 (2, 3); needles 3 and 4: K1 (2, 3), work Rnd 1 of Argyle chart over 28 sts, k1 (2, 3).

Cont in patt through Rnd 46 of chart on needles 1 and 2, then rep Rnd 1 once more.

NEXT RND: Needles 1 and 2: Knit to end of needle; needles 3 and 4: Cont working Argyle chart as est.

Cont in patt through Rnd 46 of chart on needles 3 and 4, then rep Rnd 1 once more.

CUFF

DEC RND: Needle 1: K1, ssk, knit to end of needle; needle 2: knit to last 3 sts, k2tog, k1; needle 3: K1, ssk, knit to end of needle; needle 4: knit to last 3 sts, k2tog, k1—56 (60, 64) sts rem.

Beg with a purl rnd, work 6 rnds in garter st (knit 1 rnd; purl 1 rnd), ending with a knit rnd.

BO all sts pwise.

HEEL

Carefully remove the waste yarn and place 30 (32, 34) sts from above the heel on 1 dpn for the leg and 30 (32, 34) sts from below the heel on a 2nd dpn for the sole—60 (64, 68) sts total.

NEXT RND: Needle 1: K15 (16, 17) sole sts; needle 2: K15 (16, 17) sole sts, pick up and knit 1 st through the back loop (k1tbl, see Glossary) in the gap at the edge; needle 3: K15 (16, 17) leg

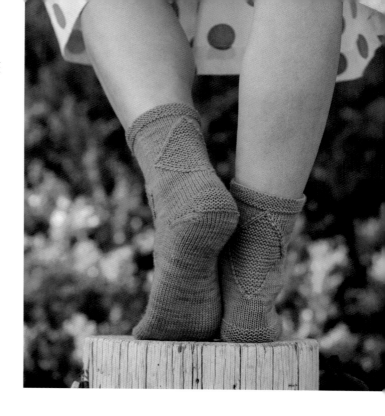

sts; needle 4: K15 (16, 17) leg sts, pick up and k1tbl in the gap at the edge—62 (66, 70) sts.

NEXT RND: Needles 1 and 2: knit; needles 3 and 4: purl.

DEC RND: Needle 1: K1, ssk, knit to end of needle; needle 2: knit to last 4 sts, k2tog, k2; needle 3: K1, ssk, knit to end of needle; needle 4: knit to last 4 sts, k2tog, k2—4 sts dec'd.

Cont in patt, working St st on the sole and garter st on the back of the heel as est, and rep dec rnd every other rnd 8 more times—26 (30, 34) sts rem.

Work 1 rnd even.

Using Kitchener stitch (see Glossary), graft the rem sts tog.

FINISHING

Weave in ends and block lightly to measurements.

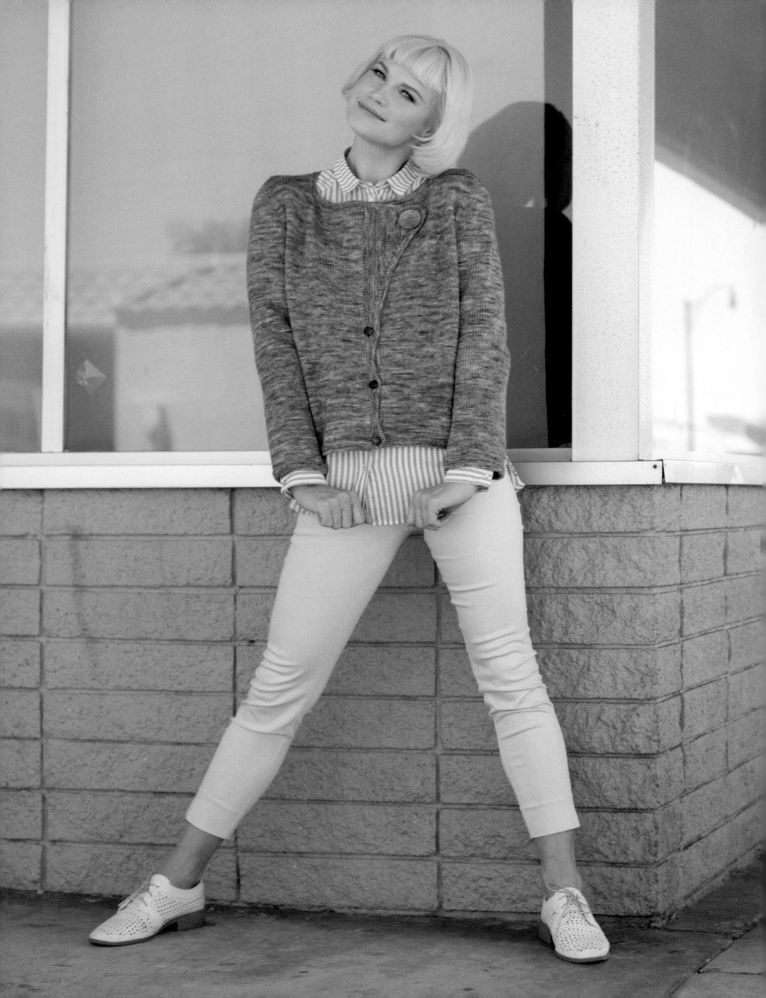

Asymmetrical Cropped Jacket

DESIGNED BY TOBY ROXANE BARNA

This sporty cropped cardigan features a garter stitch panel down the back where all waist shaping is worked, creating a flattering hourglass shape and an interesting design detail. The curved button band is shaped with short-rows for a unique accent.

FINISHED SIZE

36 (40¾, 44½, 48¾, 52½, 56¾, 61¾)" (91.5 [103.5, 113, 124, 133.5, 144, 157] cm) bust circumference, including ½" (1.3 cm) front band.

Jacket shown measures 40¾" (103.5 cm).

YARN

DK weight (#3 Light).
Shown here: Fiberstory Core DK (100% super-wash merino wool; 231 yd [211 m]/3½ oz [100 g]): Daybreak, 6 (6, 7, 8, 8, 9, 10) skeins.

NEEDLES

Size U.S. 6 (4 mm): 24" (60 cm) or longer circular (cir) and set of 4 or 5 double-pointed (dpn).
Size U.S. 5 (3.75 mm): 16" (40 cm) or longer circular (cir).
Adjust needle sizes if necessary to obtain the correct gauge.

NOTIONS

Removable markers (m); markers (2 different colors or types for marker A and marker B); tapestry needle; three ½" (12 mm) buttons; one 1½" (37 mm) button.

GAUGE

23 sts and 34 rows = 4" (10 cm) in stockinette st on larger needles, blocked.

Notes

* This jacket is worked back and forth in one piece from the top down. The back neck and shoulders are worked first, and then stitches are picked up for the sleeves and fronts and worked flat to the underarms. Sleeve stitches are put on holders, and the lower body is worked to the hem. The sleeves are worked in the round from the top down.

* Two sets of markers are used. Marker A indicates the start and end of the garter stitch back panel. Marker B indicates the start and end of each sleeve cap section.

* Although the body is worked flat, a circular needle is used to accommodate the large number of stitches.

BODY

Using larger cir needle, CO 72 (78, 83, 89, 93, 101, 106) sts. Do not join.

SET-UP ROW 1: (RS) K16 (16, 19, 19, 22, 22, 22), place removable marker (m) in next st, knit to last 17 (17, 20, 20, 23, 23, 23) sts, place removable m in next st, knit to end of row.

SET-UP ROW2: (WS) P20, place marker A (pm A), p1, k30 (36, 41, 47, 51, 59, 64), p1, pm A, purl to end of row.

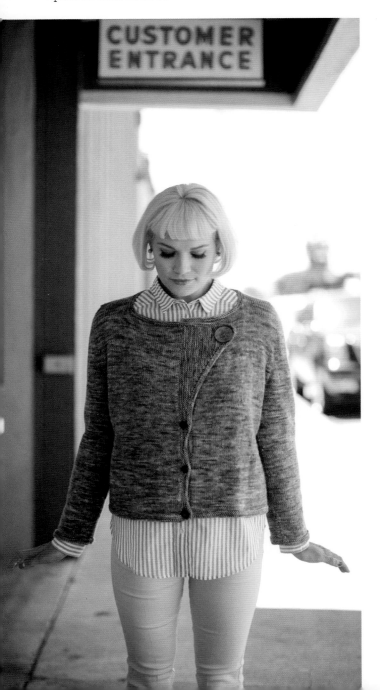

NEXT ROW: Knit to marker A (m A), slip m A (sl m A), p1, knit to 1 st before m A, p1, sl m A, knit to end.

Cont in patt, working garter st panel as between A markers, work 17 (17, 17, 17, 21, 21, 21) more rows, ending with a WS row.

Set Up Sleeves and Fronts

With RS facing and CO edge at top, beg at left removable m, pick up and knit 17 (17, 20, 20, 23, 23, 23) sts along the CO edge for left front, pm B, pick up and knit 10 (10, 10, 10, 12, 12, 12) sts along left edge for left sleeve, pm B, cont in patt across back panel, pm B, pick up and knit 10 (10, 10, 10, 12, 12, 12) sts along right edge for right sleeve, pm B, pick up and knit 17 (17, 20, 20, 23, 23, 23) sts along CO edge stopping at removable m for right front, remove both removable m—126 (132, 143, 149, 163, 171, 176) sts.

Shape Sleeve Caps

NEXT ROW: (WS) Purl to m A, sl m A, p1, knit to 1 st before m A, p1, sl m A, purl to end.

INC ROW: (RS) Knit to marker B (m B), slip m B (sl m B), k1, M1R (see Glossary), knit to 1 st before m B, M1L (see Glossary), k1, sl m B, knit to m A, sl m A, p1, knit to 1 st before m A, p1, sl m A, knit to m B, sl m B, k1, M1R, knit to 1 st before m B, M1L, k1, sl m B, knit to end of row—4 sts inc'd.

Cont in patt, rep inc row every RS row 0 (0, 0, 0, 2, 2, 2) more times—130 (136, 147, 153, 175, 183, 188) sts total; 72 (78, 83, 89, 93, 101, 106) sts for back, 17 (17, 20, 20, 23, 23, 23) sts for each front, 12 (12, 12, 12, 18, 18, 18) sts for each sleeve.

Work 1 WS row.

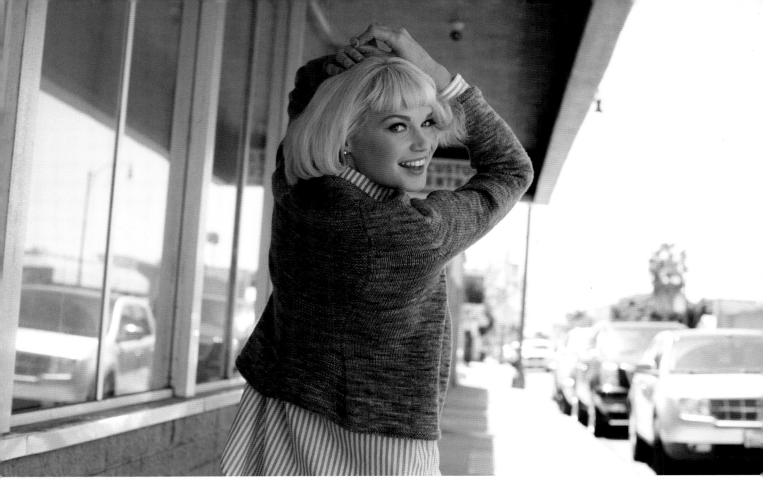

Shape Neck

INC ROW: (RS) K1, M1R, knit to m B, sl m B, k1, M1R, knit to 1 st before mB, M1L, k1, sl m B, knit to m A, sl m A, p1, knit to 1 st before m A, p1, sl m A, knit to m B, sl m B, k1, M1R, knit to 1 st before m B, M1L, k1, sl m B, knit to last st, M1R, k1—6 sts inc'd.

NEXT ROW: (WS) Purl to m A, sl m A, p1, knit to 1 st before m A, p1, sl m A, purl to end.

Rep last 2 rows once more—142 (148, 159, 165, 187, 195, 200) sts total; 72 (78, 83, 89, 93, 101, 106) sts for back, 19 (19, 22, 22, 25, 25, 25) sts for each front, 16 (16, 16, 16, 22, 22, 22) sts for each sleeve.

NEXT ROW: (RS) Using the cable method (see Glossary), CO 27 (30, 31, 34, 34, 38, 42) sts, knit to m B, sl m B, k1, M1R, knit to 1 st before m B, M1L, k1, sl m B, work in patt to m B, sl m B, k1, M1R, knit to 1 st before m B, M1L, k1, sl m B, knit to end of row.

NEXT ROW: (WS) Using the cable method, CO 27 (30, 31, 34, 34, 38, 42) sts, work in patt to end of row—200 (212, 225, 237, 259, 275, 288) sts total; 72 (78, 83, 89, 93, 101, 106) sts for back, 46 (49, 53, 56, 59, 63, 67) sts for each front, 18 (18, 18, 18, 24, 24, 24) sts for each sleeve.

Continue Shaping Sleeve Caps

INC ROW: (RS) Knit to m B, sl m B, k1, M1R, knit to 1 st before m B, M1L, k1, sl m B, work in patt to m B, sl m B, k1, M1R, knit to 1 st before m B, M1L, k1, sl m B, knit to end—2 sts inc'd.

Rep inc row every RS row 13 (12, 12, 12, 10, 14, 14) more times—256 (264, 277, 289, 303, 335, 348) sts total; 72 (78, 83, 89, 93, 101, 106)

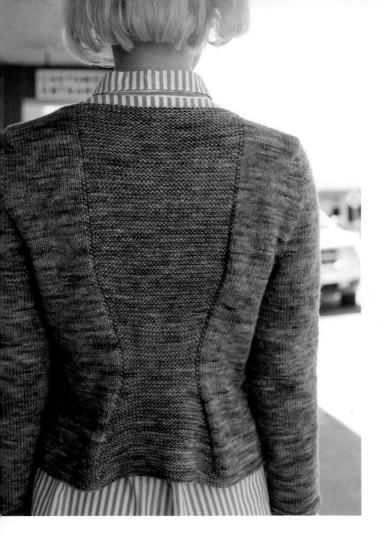

Divide Body and Sleeves

NEXT ROW: (RS) Knit to m B, remove m B, place 56 (58, 60, 62, 68, 78, 82) sleeve sts on holder, turn and, using the cable method, CO 10 (14, 16, 18, 22, 24, 28) sts for underarm, turn and work to m B, remove m B, place 56 (58, 60, 62, 68, 78, 82) sleeve sts on holder, turn and, using the cable method, CO 10 (14, 16, 18, 22, 24, 28) sts for underarm, turn and knit to end—204 (232, 253, 281, 299, 323, 352) sts for body.

Shape Waist

Beg with a WS row, cont in patt, working garter st panel between A markers, work 11 (13, 17, 13, 17, 17, 9) rows ending with a WS row.

DEC ROW: (RS) Knit to m A, sl m A, p1, ssk, knit to 3 sts before m A, k2tog, p1, sl m A, knit to end—2 sts dec'd.

Rep dec row every 6 (4, 4, 4, 4, 4, 4)th row 7 (10, 9, 10, 9, 9, 11) more times—188 (210, 233, 259, 279, 303, 328) sts rem.

Beg with a WS row, work 1 (5, 13, 13, 13, 13, 7) row(s), ending with a WS row.

INC ROW: (RS) Knit to m A, sl m A, p1, M1R, knit to 1 st before m A, M1L, p1, sl m A, knit to end—2 sts inc'd.

Rep inc row every 10 (8, 6, 6, 6, 6, 6)th row 5 (6, 7, 7, 7, 7, 8) more times—200 (224, 249, 275, 295, 319, 346) sts.

Work 1 WS row.

Shape Bottom Hem

Work short-rows as foll:

SHORT-ROW 1: (RS) Knit to m A, sl m A, p1, knit to 1 st before m A, wrap next st, turn work.

sts for back, 46 (49, 53, 56, 59, 63, 67) sts for each front, 46 (44, 44, 44, 46, 54, 54) sts for each sleeve.

Work 9 (11, 11, 13, 11, 13, 13) rows even, ending with a WS row.

INC ROW: (RS) *Work in patt to 1 st before m B, M1L, k1, sl m B, k1, M1R; rep from * 3 more times, knit to end—8 sts inc'd.

Rep inc row every RS row 4 (6, 7, 9, 10, 11, 13) more times—296 (320, 341, 369, 391, 431, 460) sts total; 82 (92, 99, 109, 115, 125, 134) sts for back, 51 (56, 61, 66, 70, 75, 81) sts for each front, 56 (58, 60, 64, 68, 78, 82) sts for each sleeve.

Work 1 WS row.

SHORT-ROW 2: (WS) Knit to 1 st before m A, wrap next st, turn work.

SHORT-ROW 3: Work in patt to end, do not work wrap tog with wrapped st.

Beg with a WS row, knit 3 rows.

BO all sts.

SLEEVE

With dpn, beg at center of underarm, pick up and knit 5 (7, 8, 9, 11, 12, 14) sts along underarm CO edge, k56 (58, 60, 64, 68, 78, 82) sleeve sts from holder, pick up and knit 5 (7, 8, 9, 11, 12, 14) sts along rem underarm CO sts—66 (72, 76, 82, 90, 102, 110) sts.

Pm and join for working in the rnd.

Knit 23 rnds.

DEC RND: K2, ssk, knit to last 4 sts, k2tog, k2—2 sts dec'd.

Rep dec rnd every 20th rnd 5 more times—54 (60, 64, 70, 78, 90, 98) sts rem.

Purl 1 rnd.

Knit 1 rnd.

Purl 1 rnd.

BO all sts kwise.

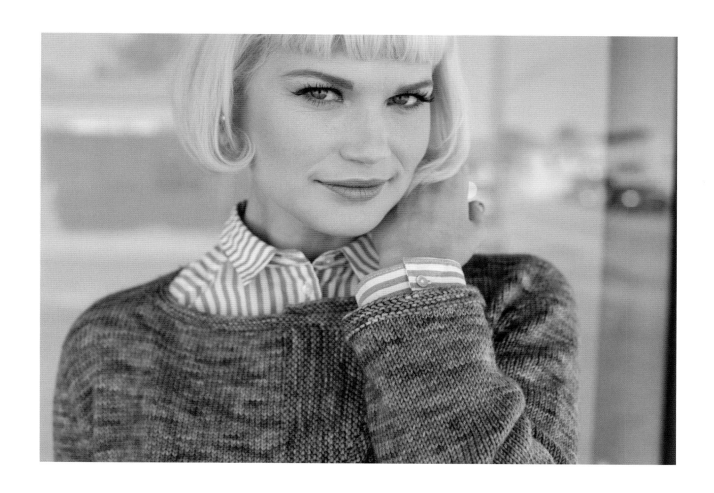

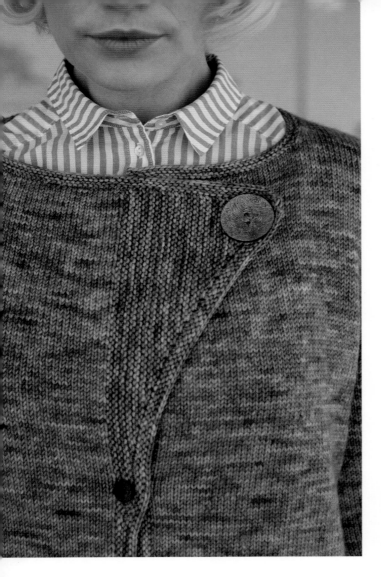

111, 119, 121) sts along center front edge, picking up 2 sts for every 3 rows.

Knit 2 rows.

BUTTONHOLE ROW: (RS) K3, *work 2-st one-row buttonhole (see Glossary), k22 (24, 25, 27, 26, 30, 31); rep from * 2 more times, knit to end.

Front Flap
Shape front flap using short-rows as foll:

SHORT-ROW 1: (WS) K56, wrap next st, turn work.

SHORT-ROW 2 AND ALL EVEN-NUMBERED SHORT-ROWS: Knit to end of row.

SHORT-ROWS 3 AND 5: Knit to 5 sts before previously wrapped st, wrap next st, turn work.

SHORT-ROWS 7, 9, 11, 13, AND 15: Knit to 3 sts before previously wrapped st, wrap next st, turn work.

SHORT-ROWS 17, 19, 21, 23, 25, 27, 29, 31, 33, AND 35: Knit to 2 sts before previously wrapped st, wrap next st, turn work.

SHORT-ROW 36: (RS) K2, work 5-st one-row buttonhole, knit to end.

SHORT-ROWS 37, 39, 41, AND 43: Rep Short-row 35.

SHORT-ROW 45: Knit to end, do not work wraps tog with wrapped sts.

Knit 2 more rows.

BO all sts.

FINISHING

Left Buttonband
With RS facing, larger cir needle, and beg at neck edge, pick up and knit 103 (107, 109, 113, 111, 119, 121) sts along center front edge, picking up 2 sts for every 3 rows.

Knit 6 rows.

BO all sts.

Right Buttonband
With RS facing, larger cir needle, and beg at lower edge, pick up and knit 103 (107, 109, 113,

Neckband

With RS facing, smaller cir needle, and beg at top right corner of right buttonband, pick up and knit 25 sts along buttonband (one st in each garter ridge), 27 (30, 31, 34, 34, 38, 42) sts along right front neck CO, 6 (6, 6, 6, 8, 8, 8) sts along right side of neck, 38 (44, 43, 49, 47, 55, 60) sts along back neck, 6 (6, 6, 6, 8, 8, 8) sts along left side of neck, 27 (30, 31, 34, 34, 38, 42) sts along left front neck CO, and 2 sts along top of left button-band—131 (143, 144, 156, 158, 174, 187) sts.

Knit 3 rows.

BO all sts.

Weave in ends. Block to measurements. Sew smaller buttons to left front buttonband opposite buttonholes. Sew larger button to left front to correspond to buttonhold in front flap.

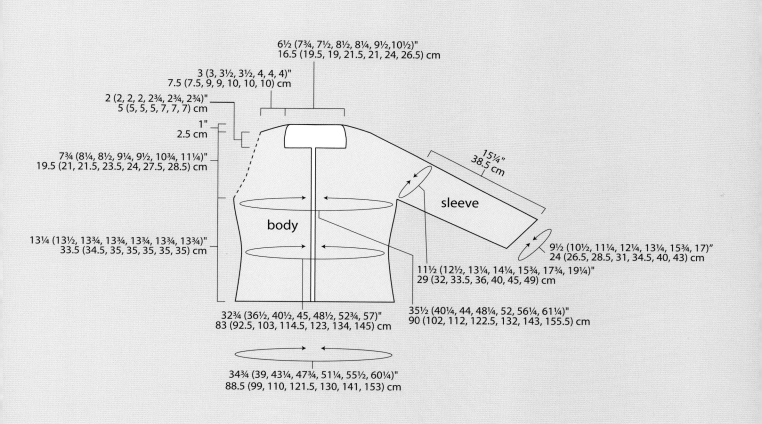

6½ (7¾, 7½, 8½, 8¼, 9½,10½)"
16.5 (19.5, 19, 21.5, 21, 24, 26.5) cm

3 (3, 3½, 3½, 4, 4, 4)"
7.5 (7.5, 9, 9, 10, 10, 10) cm

2 (2, 2, 2, 2¾, 2¾, 2¾)"
5 (5, 5, 5, 7, 7, 7) cm

1"
2.5 cm

7¾ (8¼, 8½, 9¼, 9½, 10¾, 11¼)"
19.5 (21, 21.5, 23.5, 24, 27.5, 28.5) cm

15¼"
38.5 cm

sleeve

body

13¼ (13½, 13¾, 13¾, 13¾, 13¾, 13¾)"
33.5 (34.5, 35, 35, 35, 35, 35) cm

9½ (10½, 11¼, 12¼, 13¼, 15¾, 17)"
24 (26.5, 28.5, 31, 34.5, 40, 43) cm

11½ (12½, 13¼, 14¼, 15¾, 17¾, 19¼)"
29 (32, 33.5, 36, 40, 45, 49) cm

32¾ (36½, 40½, 45, 48½, 53¾, 57)"
83 (92.5, 103, 114.5, 123, 134, 145) cm

35½ (40¼, 44, 48¼, 52, 56¼, 61¼)"
90 (102, 112, 122.5, 132, 143, 155.5) cm

34¾ (39, 43¼, 47¾, 51¼, 55½, 60¼)"
88.5 (99, 110, 121.5, 130, 141, 153) cm

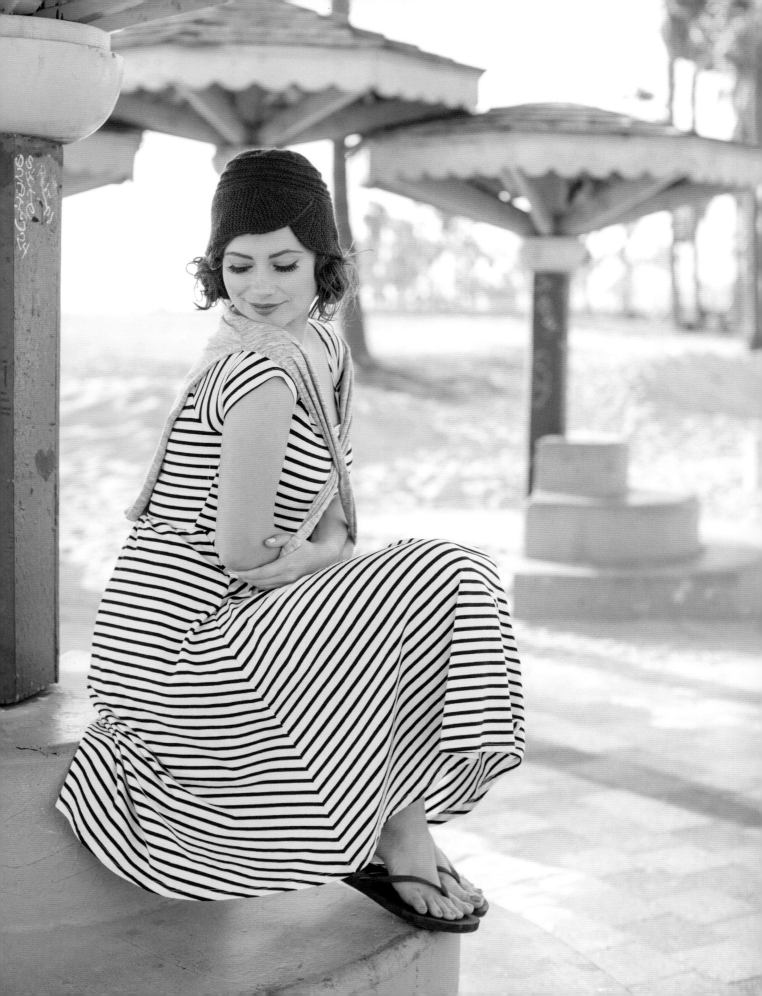

Just Peachy Saddle Shoulder Cardigan

DESIGNED BY KRISTEN TENDYKE

A classic top-down cardigan gets a fresh look when knit in a vibrant peach yarn with saddle shoulders. Garter stitch cuffs, plackets, and waistband contrast nicely with the smooth stockinette stitch fabric. Subtle waist shaping and set-in sleeves make for a flattering fit.

FINISHED SIZE:

33¼ (36½, 40, 43½, 47, 50¼, 53¾)" (84.5 [92.5, 101.5, 110.5, 119.5, 127.5, 136.5] cm) bust circumference, including 1¾" (4.5 cm) front band.

Cardigan shown measures 36½" (92.5 cm).

YARN

Chunky weight (#5 Bulky).
Shown here: Mountain Meadow Wool Sheridan (100% merino wool; 102 yd [93 m]/3½ oz [100 g]): Coral Bell, 8 (9, 10, 11, 11, 12, 13) skeins.

NEEDLES

Sizes U.S. 10 and 11 (6 and 8 mm): 32" (80 cm) circular (cir) and set of 4 or 5 double-pointed (dpn).
Adjust needle sizes if necessary to obtain the correct gauge.

NOTIONS

Markers (m); removable markers (optional); stitch holders; tapestry needle; six 1" (2.5 cm) buttons.

GAUGE

14 sts and 22 rows = 4" (10 cm) in stockinette st with larger needles, blocked.
14 sts and 28 rows = 4" (10 cm) in garter st with smaller needles, blocked.

Notes

* This cardigan is worked back and forth in one piece from the top down. The shoulder tabs are worked first, and then stitches are picked up for the fronts and back and worked to the underarms. Sleeve stitches are put on holders, and the lower body is worked to the hem. The sleeves are worked in the round from the top down.

* It may be helpful to mark the right side of the work with a removable marker or safety pin.

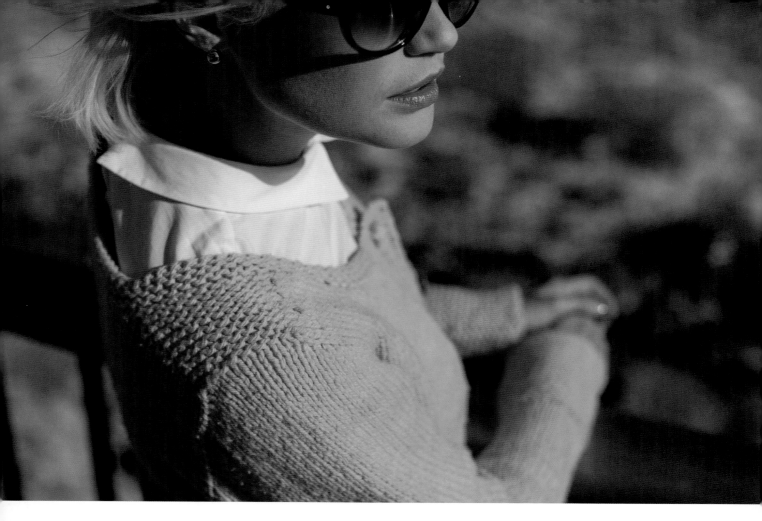

SHOULDER TAB (MAKE 2)

With smaller dpn, CO 10 sts. Do not join.

Knit 18 (20, 22, 24, 26, 28, 30) rows, ending with a WS row.

Keep sts on dpn, break yarn, and set aside.

YOKE

With RS facing, larger cir needle, and beg at the lower right corner of one shoulder tab, pick up and knit 9 (10, 11, 12, 13, 14, 15) sts along right selvedge edge (picking up 1 st in each gar-ter ridge) for left front, place marker (pm), k10 shoulder tab sts for left sleeve, pm, pick up and knit 9 (10, 11, 12, 13, 14, 15) sts along left sel-vedge edge, turn work so WS is facing, then use

the cable method (see Glossary) to CO 24 (26, 28, 30, 28, 30, 32) sts for back neck, turn, then, with RS facing, beg at lower right corner of the second shoulder tab, pick up and knit 9 (10, 11, 12, 13, 14, 15) sts along right selvedge edge, pm, k10 shoulder tab sts for right sleeve, pm, pick up and knit 9 (10, 11, 12, 13, 14, 15) sts along left selvedge edge for right front—80 (86, 92, 98, 100, 106, 112) sts; 9 (10, 11, 12, 13, 14, 15) sts for each front, 10 sts for each sleeve, 42 (46, 50, 54, 54, 58, 62) sts for back.

Shape Front Shoulders

Working in St st (knit on RS, purl on WS), shape shoulders using short-rows as foll:

Right shoulder

SHORT-ROW 1: (WS) P2 (2, 3, 3, 3, 3, 4), wrap next st, turn work.

Rep dec rnd every 8 (8, 6, 6, 4, 4, 4)th rnd 3 (7, 4, 8, 1, 4, 10) more time(s), then every 10th (0, 8th, 8th, 6th, 6th, 6th) rnd 3 (0, 4, 1, 9, 7, 3) time(s)—30 (32, 32, 34, 34, 36, 36) st rem.

Work even in St st until piece measures 13½" (34.5 cm) from underarm.

Change to smaller dpn and work in garter st in the rnd (purl 1 rnd, knit 1 rnd) for 5" (12.5 cm), ending with a knit rnd.

BO all sts pwise.

FINISHING

Block to measurements.

Neckband

With smaller cir and RS facing, beg at right front neck edge, pick up and knit 6 (7, 7, 8, 7, 8, 8) sts along front neck CO sts, 6 sts along right front neck to shoulder tab, 10 sts along shoulder tab, 22 (24, 26, 28, 26, 28, 30) sts across back neck, 10 sts along shoulder tab, 6 sts along left front neck to CO sts, then 6 (7, 7, 8, 7, 8, 8) sts along CO sts—66 (70, 72, 76, 72, 76, 78) sts.

Knit 4 rows, ending with a RS row.

BO all sts kwise.

Buttonband

With smaller cir and RS facing, beg at left front neck edge, pick up and knit 81 (83, 85, 87, 89, 91, 95) sts evenly along left front.

Knit 12 rows, ending with a RS row.

BO all sts kwise.

Buttonhole Band

With smaller cir and RS facing, beg at right front lower edge, pick up and knit 81 (83, 85, 87, 89, 91, 95) sts evenly along right front, including neckband.

Knit 5 rows, ending with a WS row.

Buttonhole row: (RS) K4 (6, 8, 5, 7, 4, 8) *work 3-st one-row buttonhole (see Glossary), k10 (10, 10, 11, 11, 12, 12); rep from * 4 more times, work 3-st one-row buttonhole, knit to end.

Knit 6 more rows, ending with a RS row.

BO all sts kwise.

Sew buttons to buttonband opposite button-holes. Weave in ends. Block again.

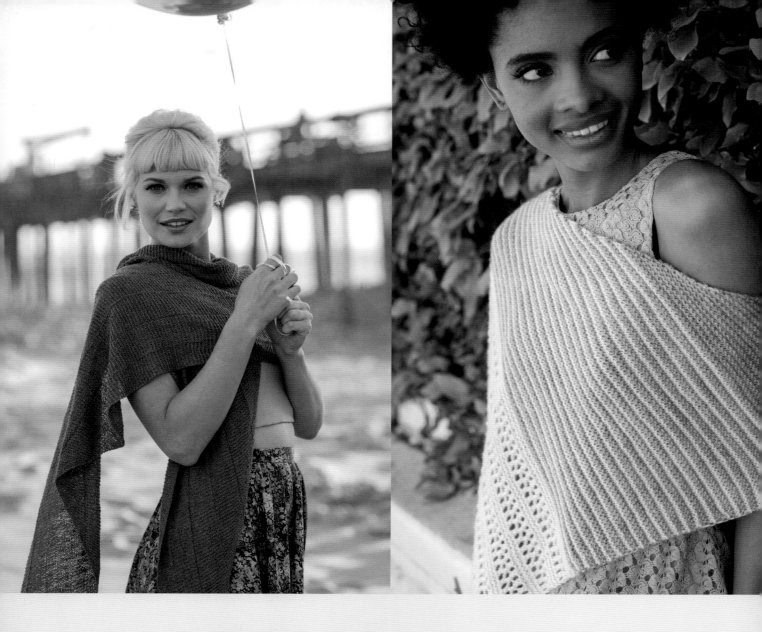

CHAPTER TWO

garter stitch in a supporting role

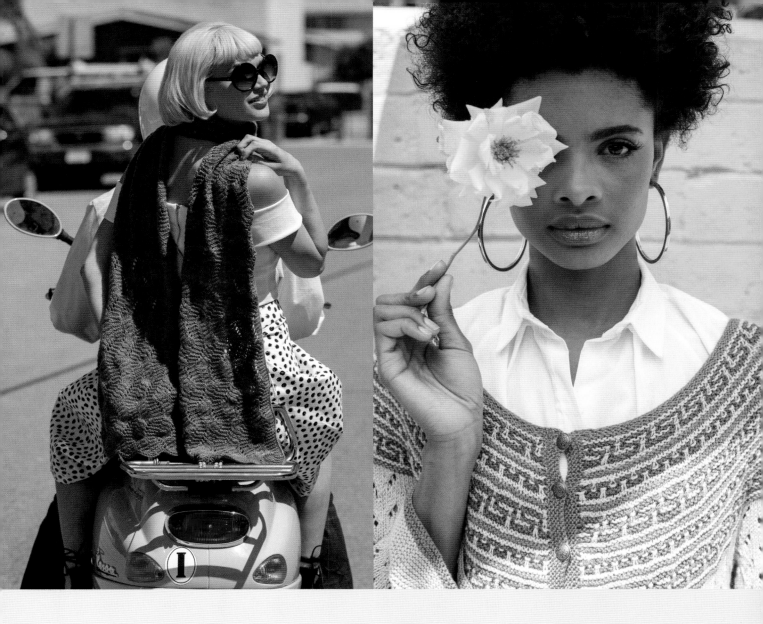

Garter stitch provides just the right balance to other stitch patterns without overshadowing them. It sets off lace beautifully, in Anne Podlesak's Coney Island Shawl, contrasts nicely with brioche in Jessie Ksanznak's Boardwalk Brioche Cowl, and adds interest to colorwork in Amy Gunderson's Cotton Candy Mosaic Yoke Cardigan.

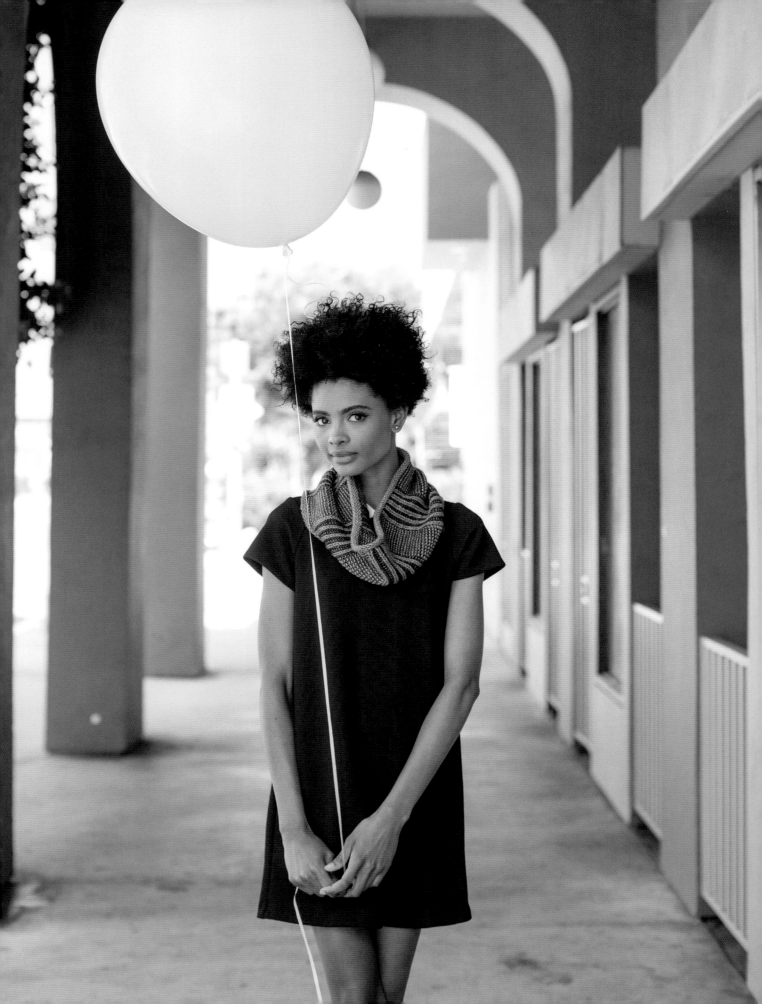

Beachcomber Braided Poncho

DESIGNED BY HEATHER ZOPPETTI

The design of this stunning poncho couldn't be simpler—a large garter stitch rectangle folded in half and buttoned along one side. Stitches are dropped while binding off and then picked up to create columns of braids for a simple, yet sophisticated detail. Slip it on for your morning stroll on the beach.

FINISHED SIZE

24" (61 cm) wide and 56" (142 cm) long.

YARN

Chunky weight (#5 Bulky).
Shown here: Stitch Sprouts Crater Lake (100% superwash merino wool; 110 yd [101 m]/3½ oz [100 g]): #SSC001 Old Man, 8 skeins.

NEEDLES

Size U.S. 10½ (6.5 mm): 24" (60 cm) circular (cir).
Adjust needle size if necessary to obtain the correct gauge.

NOTIONS

Markers (m); crochet hook; tapestry needle; four ⅝" (1.5 cm) buttons.

GAUGE

15 sts and 23 rows = 4" (10 cm) in garter st, blocked.

Note

* Slip the first stitch of every row purlwise with yarn in front.

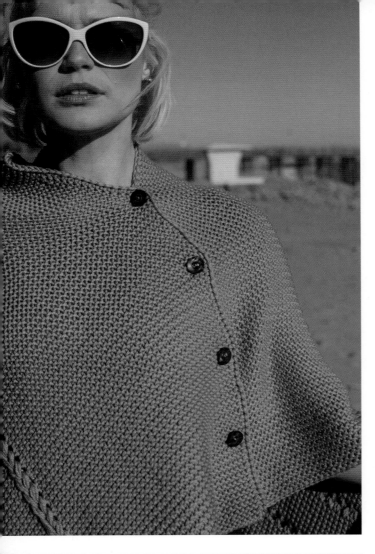

STITCH GUIDE

DECORATIVE BRAID PATTERN: Drop the next 3 sts all the way to the bottom (Figure 1), then with crochet hook, working bottom 5 strands tog, half twist to form a loop (Figure 2), *pick up next 4 strands and draw through loop on hook; rep from * to top (Figure 3), slip loop on hook onto left needle, working one strand at a time, in any order, BO the 4 strands (Figure 4).

PONCHO

Using the long-tail method (see Glossary), CO 96 sts.

NEXT ROW: Sl 1 (see Note), knit to end of row.

Rep last row 26 more times, ending with a WS row.

BUTTONHOLE ROW: (RS) Sl 1, k1, k2tog, yo, knit to end of row.

Cont in patt and rep buttonhole row every 26th row 3 more times. Piece should measure 18" (45.5 cm) from CO.

Work 58 more rows to center until piece measures 28" (71 cm) from CO. Work 163 more rows, ending with a WS row for second half of poncho. Piece should measure 56" (142 cm).

Work Braids
NEXT ROW: (RS) BO 41 sts, *work Decorative Braid Pattern (see Stitch Guide) over next 3 sts, BO 8 sts; rep from * to end, fasten off last st.

FINISHING

Block to measurements. Weave in ends. Fold in half and sew buttons opposite buttonholes.

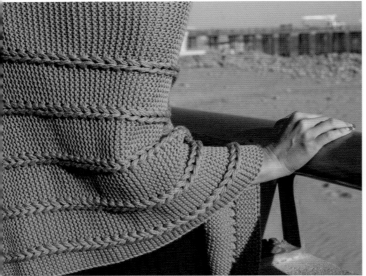

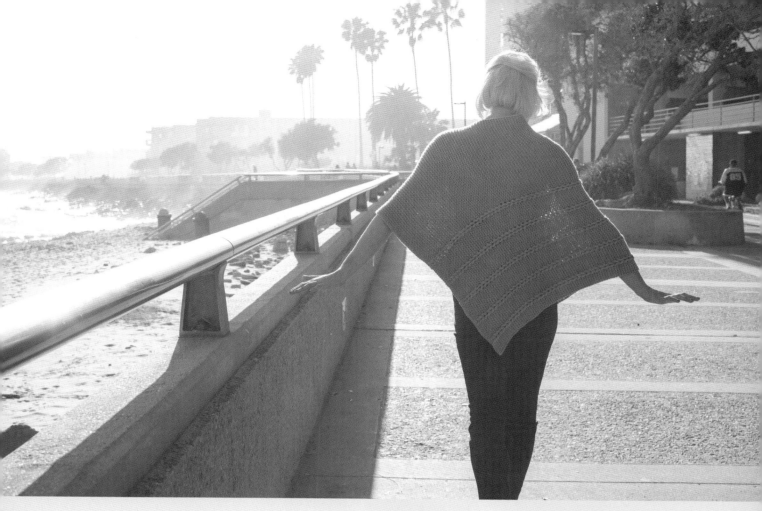

FIGURE 1

FIGURE 2

FIGURE 3

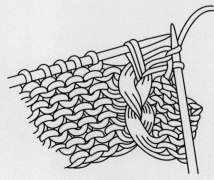

FIGURE 4

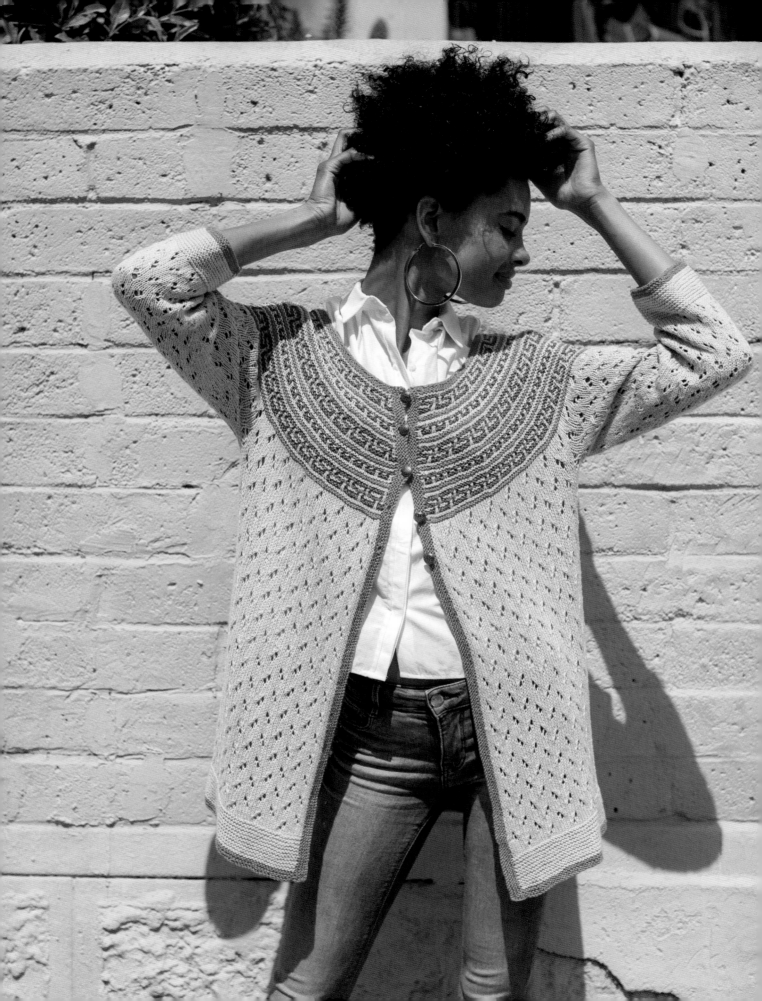

Coney Island Shawl

DESIGNED BY ANNE PODLESAK

Inspired by 1920s Coney Island and the summery floral dresses that ladies wore while walking along the pier, this lovely triangular wrap will hold cool ocean breezes at bay. Warm yellow solid and striped garter stitch sections provide a subtle color shift to the creamy lace-mesh border.

FINISHED SIZE

56" (142 cm) wide and 24" (61 cm) long.

YARN

DK weight (#3 Light).
Shown here: Wooly Wonka Fibers Freya DK (100% blue-faced Leicester wool; 300 yd [274 m]/3½ oz [100 g]): Parchment (MC), 2 skeins; Brocade (CC), 1 skein.

NEEDLES

Size U.S. 7 (4.5 mm): 36" (90 cm) circular (cir).
Adjust needle size if necessary to obtain the correct gauge.

NOTIONS

Markers (m); removable marker (optional); tapestry needle.

GAUGE

20 sts and 32 rows = 4" (10 cm) in Garter Stripe Pattern, blocked.

Notes

* Work decreases at the edge of the shawl loosely to help keep a stretchy top edge.

* It may be helpful to mark the right side of the work with a safety pin or removable marker.

* When working the garter stripe section, do not break yarn at color changes. Carry unused color up side of work and bring new color up under color just used.

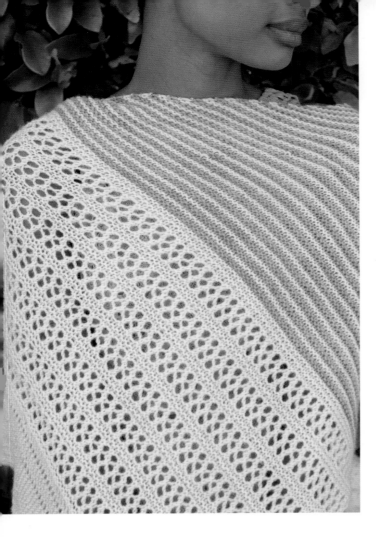

Knit 1 WS row.

Work Rows 1–32 of Border chart 8 times, then work Rows 1–31 once more, ending with a RS row.

BO all sts, but do not fasten off last st. Do not turn.

With WS facing, pick up and knit (see Glossary) 143 sts along top edge of border, picking up 1 st in each garter ridge—144 sts.

Knit 2 rows, ending with a WS row.

LACE MESH SECTION

Work Rows 1–20 of Lace Mesh chart 3 times, then work Rows 1–10 once more—109 sts rem.

GARTER STRIPE SECTION

Join CC.

Work Rows 1–4 of Garter Stripe Pattern (see Stitch Guide) 20 times—69 sts.

Break MC and cont with CC only.

STITCH GUIDE

Garter Stripe Pattern
ROW 1: (RS) With CC, knit.

ROW 2: (WS) With CC, ssk, knit to end—1 st dec'd.

ROW 3: With MC, knit.

ROW 4: With MC, ssk, knit to end—1 st dec'd.

Rep Rows 1–4 for Garter Stripe Pattern.

BORDER

With MC and cir needle, using the long-tail method (see Glossary), CO 16 sts. Do not join.

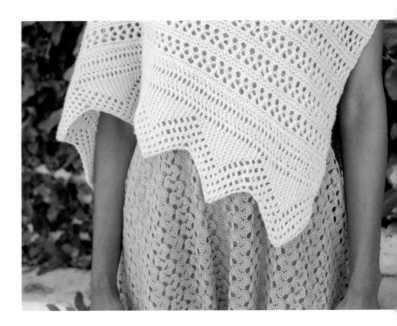

BORDER CHART

Chart with row numbers (odd): 1, 3, 5, 7, 9, 11, 13, 15, 17, 19, 21, 23, 25, 27, 29, 31

16 sts to 25 sts to 16 sts

LACE MESH CHART

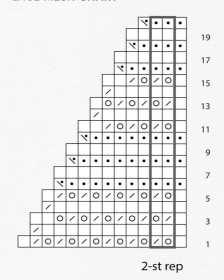

Chart with row numbers (odd): 1, 3, 5, 7, 9, 11, 13, 15, 17, 19

2-st rep

☐ knit on RS rows; purl on WS rows		☑ p2tog on RS rows; k2tog on WS rows
• knit on WS rows		☒ ssk on WS rows
○ yo		⃭ p3tog on WS rows
╱ k2tog on RS rows; p2tog on WS rows		☐ pattern rep

GARTER STITCH SECTION

NEXT ROW: (RS) Knit.

DEC ROW: (WS) Ssk, knit to end—1 st dec'd.

Rep last 2 rows 65 more times—3 sts rem.

Loosely BO all sts.

FINISHING

Weave in ends. Wet block to measurements, pinning out each point of the border.

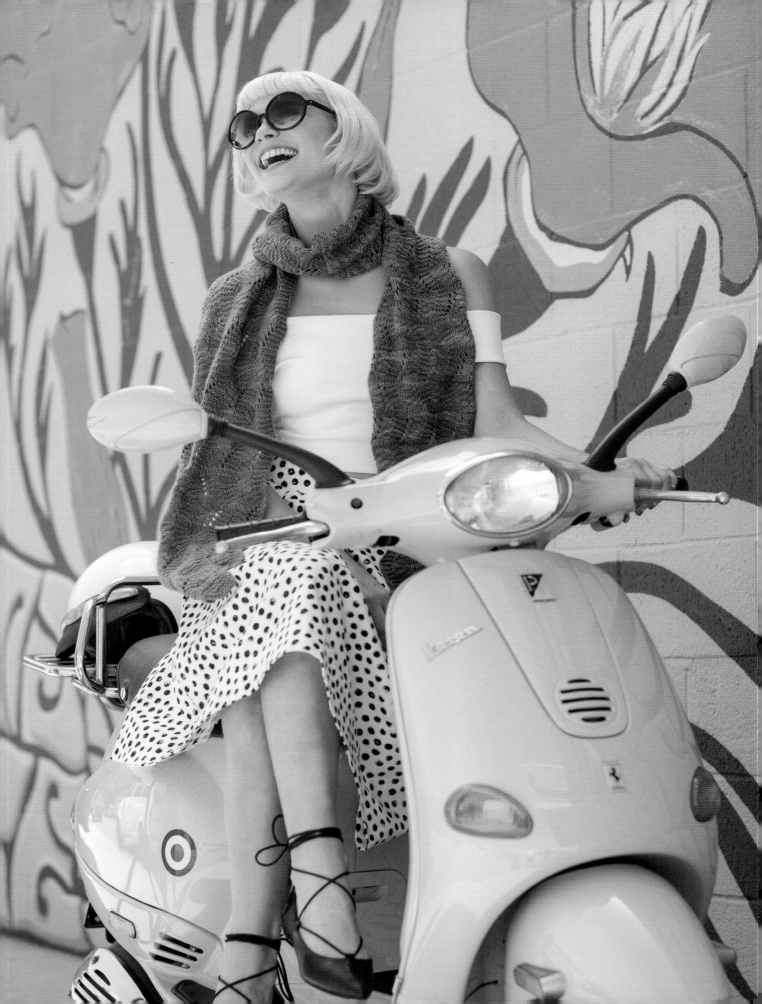

Santa Monica Cardigan

DESIGNED BY HOLLI YEOH

Knit in a luxurious merino-cashmere blend, this flowy cardigan is both elegant and playful. The garter stitch back wraps around the sides and merges into a staggered pattern that flows into stockinette. The result is a lovely, undulating front edge.

FINISHED SIZE
14½ (16¼, 18¼, 20, 21¾, 23½, 25½, 27½)"
(37 [41.5, 46.5, 51, 55, 59.5, 65, 70] cm) wide across back from center of underarm to center of underarm.

Cardigan shown measures 16¼" (41.5 cm).

YARN
Fingering weight (#1 Super Fine).
Shown here: SweetGeorgia Yarns CashLuxe Fine (70% superwash merino wool, 20% cashmere, 10% nylon; 400 yd [365 m]/4 oz [115 g]): Ultraviolet, 4 (4, 5, 5, 6, 6, 7, 7) skeins.

NEEDLES
Sizes U.S. 4 and 5 (3.5 and 3.75 mm): 32" (80 cm) or longer circular (cir).
Adjust needle sizes if necessary to obtain the correct gauge.

NOTIONS
Markers (m); stitch holders; tapestry needle.

GAUGE
26 sts and 36 rows = 4" (10 cm) in garter st on larger needle, blocked and measured while hanging (see Notes).
26 sts and 35 rows = 4" (10 cm) in stockinette st on larger needle, blocked.

Notes

* This cardigan is worked back and forth in one piece to the armholes, and then the fronts and back are worked separately. The sleeves are worked flat separately.

* Circular needles are used to accommodate the large number of stitches.

* The garter stitch sections are very elastic, so the cardigan will lengthen when worn. The garter stitch row gauge, the measurements given in the instructions, and the schematic measurements all account for this stretch. For a good fit, choose a size that fits closely across the back, and, when checking measurements against the instructions, hold the work vertically and slightly elongate the piece.

* When swatching for gauge, aim for a row gauge of 40 rows = 4" (10 cm) when the blocked swatch is at rest. Stretch the swatch slightly or hang it with some weights along the bottom edge (clothes pins will work) to determine the hanging gauge.

* The staggered pattern along the front openings is longer than the adjacent garter stitch area. This will result in a curved and undulating front edge. This effect can be further encouraged by separately fanning and blocking the opening edges.

* The cardigan shown used almost all of the yarn called for. Consider purchasing an extra skein as insurance.

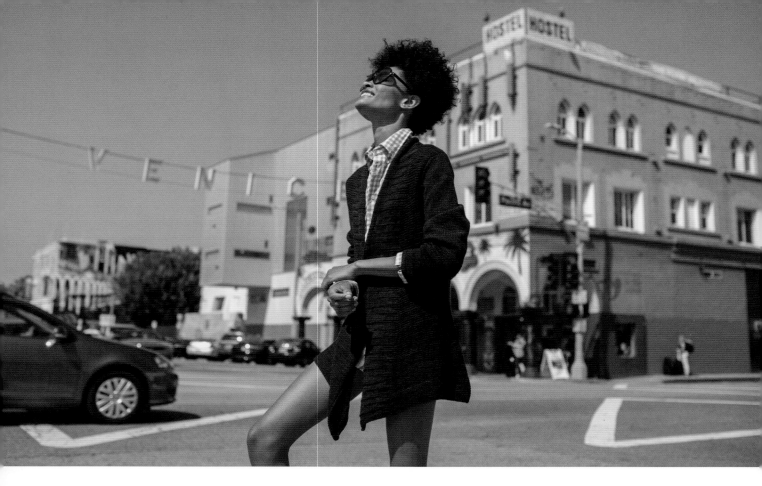

BODY

With smaller needle, CO 310 (324, 356, 388, 418, 457, 473, 489) sts.

ROW 1: (RS) P5, knit to last 5 sts, p5.

ROW 2: (WS) Knit.

Cont in patt as est, work 3 more rows, ending with a RS row.

NEXT ROW: (WS) K33, place marker (pm) for left front panel, k60 (64, 74, 84, 93, 105, 110, 115), pm for side, k10, pm for side, k104 (110, 122, 134, 146, 161, 167, 173), pm for side, k10, pm for side, k60 (64, 74, 84, 93, 105, 110, 115), pm for right front panel, knit to end of row.

Change to larger needle.

NEXT ROW: (RS) Work Right Staggered chart to m, slip marker (sl m), knit to last m, sl m, work Left Staggered chart to end of row.

NEXT ROW: Work chart to m, sl m, knit to last m, sl m, work chart to end of row.

Shape Front

Note: Waist shaping begins before front panel taper ends. Read the following section all the way through before proceeding.

DEC ROW: (RS) Work to m, sl m, k2tog, work to 2 sts before last m, ssk, sl m, work to end of row—2 sts dec'd.

Rep dec row every 6th (6th, 4th, 4th, 4th, 2nd, 2nd, 2nd) row 7 (23, 11, 23, 33, 5, 11, 15) more times, then every 8 (8, 6, 6, 6, 4, 4, 4)th row 14 (2, 18, 10, 3, 35, 31, 29) times.

RIGHT STAGGERED CHART

(chart, 33 sts wide, rows 1–13 odd numbers labeled at right)

33 sts

LEFT STAGGERED CHART

(chart, 33 sts wide, rows 1–13 odd numbers labeled at right)

33 sts

▢	knit on RS rows; purl on WS rows
•	purl on RS rows; knit on WS rows

At the same time, work 3 rows, ending with a WS row. Piece should measure 1¾" (4.5 cm) from CO.

Shape Waist

Cont front taper and beg to shape waist as foll:

DEC ROW: (RS) Work to m, sl m, *work to 2 sts before m, ssk, sl m, work to m, sl m, k2tog; rep from * once more, work to end of row—4 sts dec'd.

Rep dec row every 4 (4, 4, 6, 6, 6, 8, 12)th row 14 (5, 3, 8, 7, 14, 3, 2) more times, then every 6th (6th, 6th, 8th, 8th, 0, 10th, 14th) row 3 (9, 11, 4, 5, 0, 6, 4) times—68 (80, 92, 108, 120, 131, 147, 159) sts rem between back m.

Cont with front taper only, work 19 rows, ending with a WS row.

Cont front taper, cont to shape waist as foll:

INC ROW: (RS) Work to m, sl m, *work to 1 st before m, k1 into front and back (k1f&b, see Glossary), sl m, work to m, sl m, k1f&b; rep from * once more, work to end of row—4 sts inc'd.

Rep inc row every 4th row 5 (5, 7, 2, 4, 5, 2, 0) more times, then every 6th row 2 (2, 0, 3, 1, 0, 1, 4) time(s)—84 (96, 108, 120, 132, 143, 155, 169) sts between back m.

Cont to end of front taper dec's—226 (244, 268, 292, 316, 339, 363, 391) sts rem; 84 (96, 108, 120, 132, 143, 155, 169) sts for back, 61 (64, 70, 76, 82, 88, 94, 101) sts for each front, 10 sts between side m. Piece should measure 18 (18, 18, 18, 17¾, 17¾, 17¼, 17¼)" (45.5 [45.5, 45.5, 45.5, 45, 45, 44, 44] cm) from CO (see Notes).

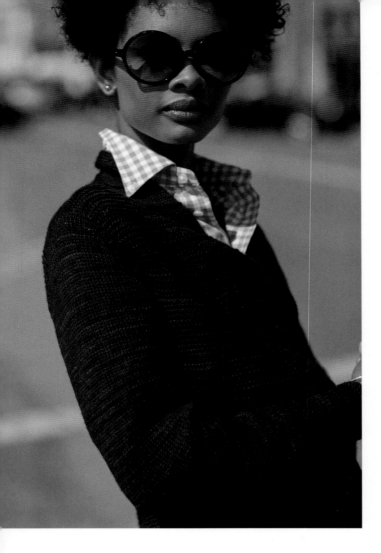

Divide for Fronts and Back

NEXT ROW: (WS) Work to m, sl m, *work to 0 (1, 3, 4, 6, 7, 10, 12) st(s) before m, BO 10 (12, 16, 18, 22, 24, 30, 34) sts, removing side m; rep from * once more, work to end of row—61 (63, 67, 72, 76, 81, 84, 89) sts for each front, 84 (94, 102, 112, 120, 129, 135, 145) sts for back.

Place back and left front sts on holders.

RIGHT FRONT

Shape Armhole

Note: Armhole shaping and front panel taper are worked at the same time. Read the following section all the way through before proceeding.

DEC ROW: (RS) Work to last 4 sts, ssk, k2—1 st dec'd.

Rep dec row every RS row 5 (6, 7, 9, 10, 11, 14, 16) more times.

At the same time, taper front as foll:

DEC ROW: (RS) Work to m, sl m, k2tog, work to end of row—1 st dec'd.

Rep dec row every 4 (6, 6, 6, 4, 4, 4, 4)th row 1 (2, 3, 4, 3, 7, 4, 7) more time(s), then every 6 (8, 8, 8, 6, 6, 6, 6)th row 3 (2, 2, 2, 6, 4, 7, 5) times—50 (51, 53, 55, 55, 57, 57, 59) sts rem.

Work even until armhole measures 5 (5½, 6, 6½, 7¼, 7½, 8, 8)" (12.5 [14, 15, 16.5, 18.5, 19, 20.5, 20.5] cm), ending with a WS row.

Shape Shoulder

Shape shoulder using short-rows as foll:

SHORT-ROW 1: (RS) Work to last 4 (4, 4, 5, 5, 5, 5, 5) sts, wrap next st, turn work.

SHORT-ROW 2 AND ALL WS ROWS: Work in patt to end of row.

SHORT-ROW 3: Work to 4 (4, 4, 5, 5, 5, 5, 5) sts before previously wrapped st, wrap next st, turn work.

SHORT-ROW 5: Work to 3 (4, 4, 4, 4, 5, 5, 5) sts before previously wrapped st, wrap next st, turn work.

SHORT-ROW 7: Work to 3 (3, 4, 4, 4, 5, 5, 5) sts before previously wrapped st, wrap next st, turn work.

SHORT-ROW 8: Work to end of row.

Arrowhead Stole

DESIGNED BY COURTNEY SPAINHOWER

Easily executed pleats transform humble garter stitch into a delicate, elegant wrap. The chain-ply linen yarn creates a crisp fabric that is suitable for warmer months and transitional seasons. Tassels keep the design lively. Instructions are provided for both a narrow scarf and a wide stole.

FINISHED SIZE

9¾ (18)" (25 [45.5] cm) wide and 51 (116)" (128 [295] cm) long.

Stole shown is 18" x 116" (45.5 x 295 cm).

YARN

Fingering weight (#1 Super Fine).
Shown here: Shibui Linen (100% linen; 246 yd [225 m]/1¾ oz [50 g]): 2022 Mineral, 3 (5) skeins.

Needles

Size U.S. 5 (3.75 mm): straight.
Adjust needle size if necessary to obtain the correct gauge.

NOTIONS

Markers (m); removable marker (optional); tapestry needle.

GAUGE

32 sts and 34 rows = 4" (10 cm) in garter st, blocked.

Notes

* This stole is worked from end to end. Increase along the right side for the first point, work even through the center, then decrease along the left side for the second point.

* It may be helpful to mark the right side of the work with a removable marker or a safety pin.

* After completing tassels, tying a small knot at the end of each strand will prevent the chain ply yarn from unraveling.

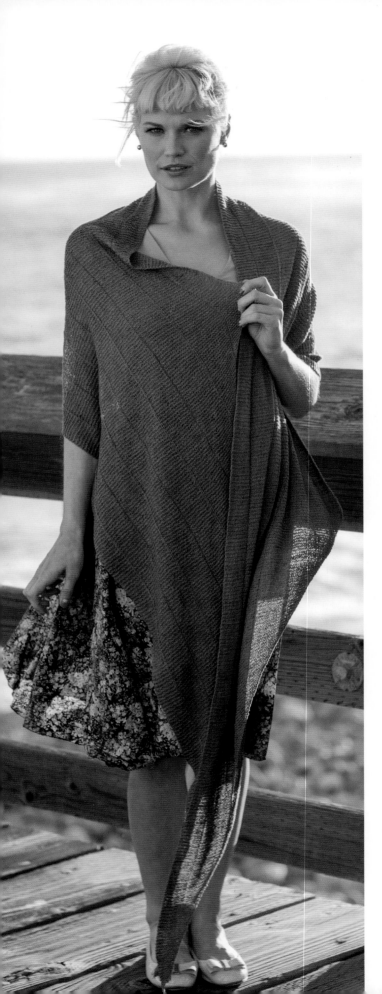

STITCH GUIDE

Pleat Pattern (multiple of 32 + 15 sts)
ROW 1: K15, *p1, k31; rep from * to end of row.

Rep Row 1 every row for Pleat Pattern.

Pleat Increase Pattern
ROW 1: (RS) K1 front and back (k1f&b, see Glossary), k14, *p1, k31; rep from * to end of row—1 st inc'd.

ROW 2: Work in Pleat Pattern (see Stitch Guide) to last st, place marker (pm), k1.

ROW 3: K1f&b, (sl m), work in Pleat Pattern to end of row—1 st inc'd.

ROWS 4 AND 6: Work in Pleat Pattern to m, sl m, p1, knit to end of row.

ROW 5: K1f&b, knit to m, sl m, work in Pleat Pattern to end of row—1 st inc'd.

ROWS 7–36: Rep Rows 5 and 6—15 sts inc'd.

ROW 37: K1f&b, pm, p1, knit to m, sl m, work in Pleat Pattern to end of row—1 st inc'd.

ROWS 38 AND 40: Rep Row 4.

ROW 39: K1f&b, knit to m, sl m, p1, knit to m, sl m, work in Pleat Pattern to end of row—1 st inc'd.

ROWS 41–64: Rep Rows 39 and 40, removing m on last row—12 sts inc'd.

STOLE

CO 1 st.

NEXT ROW: (RS) K1f&b—2 sts.

Knit 1 WS row.

INC ROW: (RS) K1f&b, knit to end of row—1 st inc'd.

Cont in garter st (knit every row), rep inc row every RS row 14 more times—17 sts.

NEXT ROW: (WS) K15, p1, knit to end of row.

Rep inc row—18 sts.

Rep last 2 rows 15 more times—33 sts.

Work 1 WS row.

INC ROW: (RS) K1f&b, place marker (pm), p1, knit to end of row—34 sts..

NEXT ROW: (WS) K15, p1, knit to end of row.

INC ROW: K1f&b, knit to m, slip m (sl m), p1, knit to end of row—1 st inc'd.

Rep last 2 rows 12 more times—47 sts.

Work 1 WS row, removing m.

Work Rows 1–64 of Pleat Increase Pattern (see Stitch Guide) 1 (3) times—79 (143) sts.

Work even in Pleat Pattern until piece measures 33 (83)" from CO, ending with a WS row.

DEC ROW: (RS) Work in patt to last 2 sts, k2tog—1 st dec'd.

Rep dec row every RS row 76 (140) more times—2 sts rem.

NEXT ROW: K2tog—1 st rem.

Break yarn and fasten off.

FINISHING

Weave in ends. Wet block.

Make 2 Tassels
Make two 18" (45.5 cm) tassels (see Glossary), wrapping yarn 20 times and cinching tassel 1" (2.5 cm) from top (see Notes).

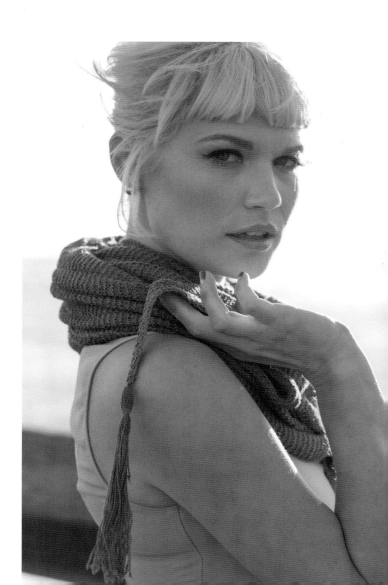

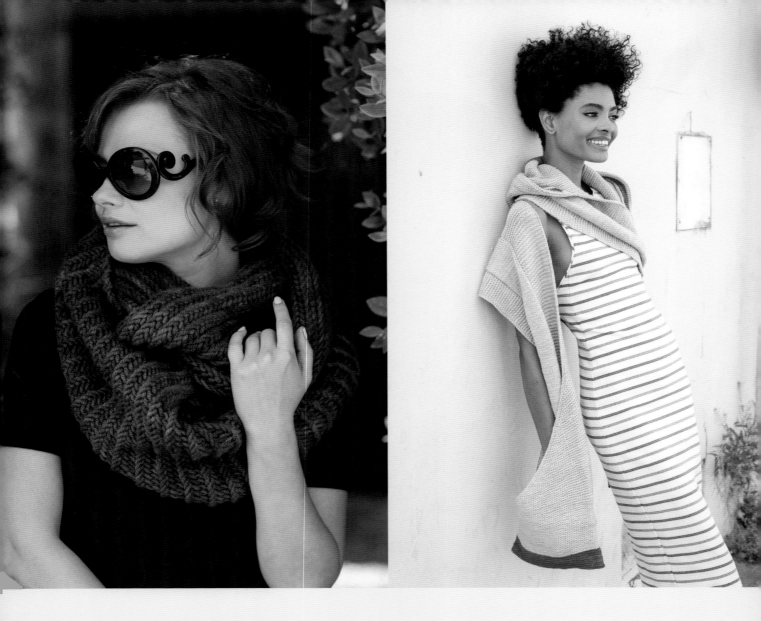

CHAPTER THREE

garter
stitch all over

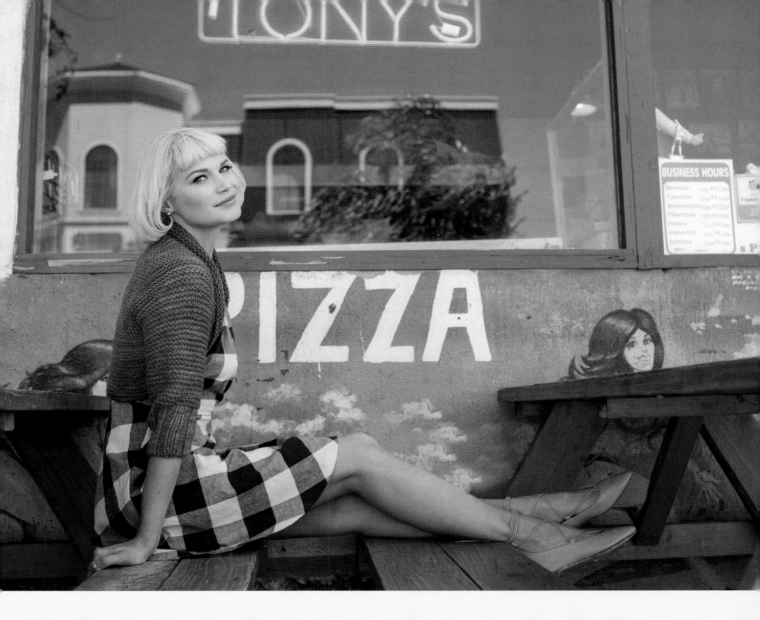

In this chapter, garter stitch takes center stage. The designers featured here demonstrate that a mostly garter stitch design can be so much more exciting than beginner scarves. Sachiko Burgin's Festival Halter Top shows that garter stitch is anything but frumpy. Holli Yeoh's Blackcomb Cowl is a sumptuous piece that makes the most of garter stitch's stretchy, supple fabric, and garter stitch stripes take a dramatic turn in Annie Rowden's Venice Beach Wrap.

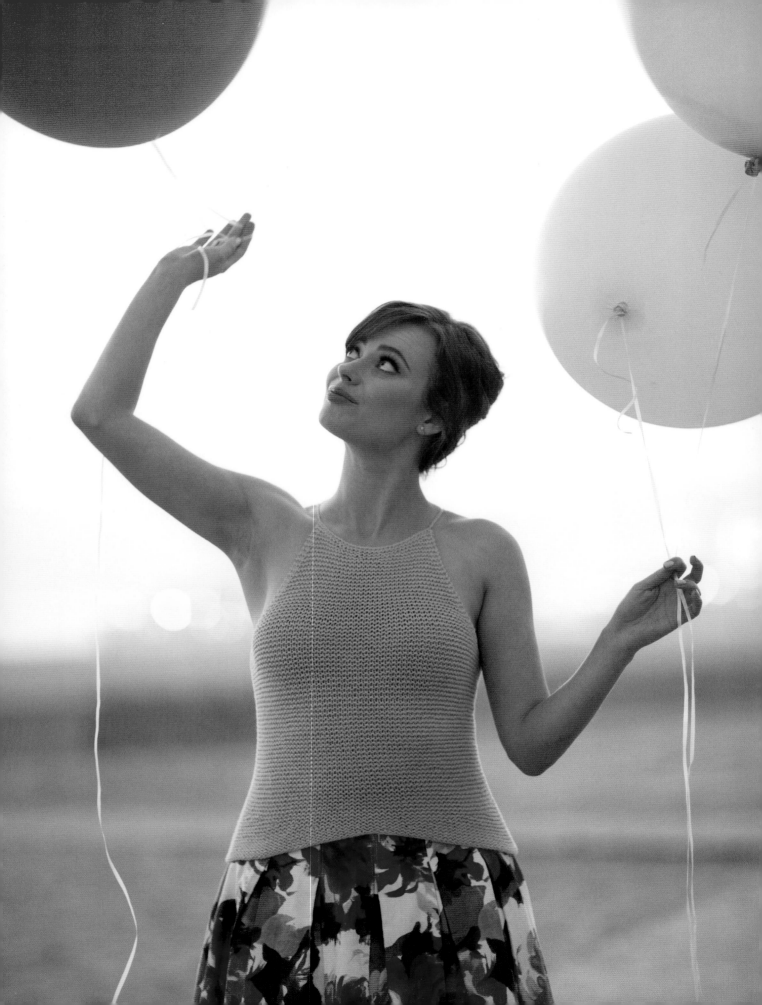

Festival Halter Top

DESIGNED BY SACHIKO BURGIN

The knit and crochet tops popular at music festivals of the '60s and '70s inspired this updated halter style top. The front and back are almost identical, except for one key detail—the gently sloping hems. With the use of short-rows, the angled garter ridges create striking visual lines that are both flattering and interesting on an otherwise plain fabric.

FINISHED SIZE

25 (28½, 33, 37, 41¼, 44½)" (63.5 [72.5, 84, 94, 105, 113] cm) bust circumference; wear halter top with 3–5" (7.5–12.5 cm) negative ease.

Halter top shown measures 28½" (72.5 cm).

YARN

Aran weight (#4 Medium).
Shown here: Rowan Softknit Cotton (92% cotton, 8% polyamide; 115 yd [105 m]/1¾ oz [50 g]): #587 Willow, 4 (5, 5, 7, 7, 8) balls.

NEEDLES

Size U.S. 8 (5 mm): straight.
Adjust needle size if necessary to obtain the correct gauge.

NOTIONS

Tapestry needle; size U.S. 7 (4.5 mm) crochet hook.

GAUGE

19 sts and 34 rows = 4" (10 cm) in garter st, blocked.

Notes

* Halter top is worked flat in two pieces from the bottom up.

* The garter stitch in this top is very elastic, so it will lengthen when worn. The garter stitch row gauge measurements given in the instructions and the schematic measurements account for this stretch. When checking measurements against the instructions, hold the work vertically and slightly elongate the piece.

FRONT

CO 60 (68, 78, 88, 98, 106) sts.

Knit 1 row.

Shape Lower Edge

Shape lower edge using short-rows as foll:

SHORT-ROW 1: (RS) K28 (32, 37, 42, 47, 51), wrap next st, turn work.

SHORT-ROW 2: (WS) Knit to end of row.

NEXT ROW: Knit to end of row, but do not work wrap tog with wrapped st.

SHORT-ROW 3: (WS) K28 (32, 37, 42, 47, 51), wrap next st, turn work.

NEXT ROW: (RS) Knit to end of row.

NEXT ROW: (WS) Knit to end of row.

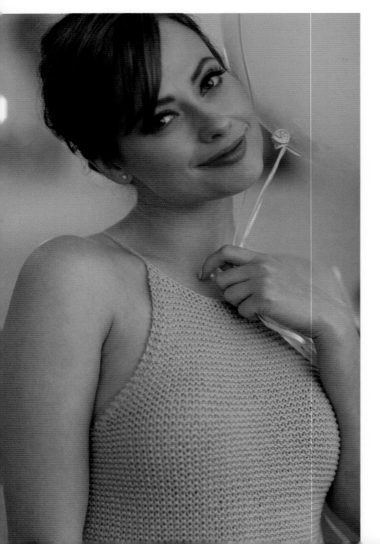

SHORT-ROW 4: (RS) K24 (28, 32, 36, 41, 44), wrap next st, turn work.

NEXT ROW: (WS) Knit to end of row.

NEXT ROW: (RS) Knit to end of row.

SHORT-ROW 5: (WS) K24 (28, 32, 36, 41, 44), wrap next st, turn work.

NEXT ROW: (RS) Knit to end of row.

NEXT ROW: (WS) Knit to end of row.

SHORT-ROW 6: (RS) K20 (24, 27, 30, 34, 37), wrap next st, turn work.

NEXT ROW: (WS) Knit to end of row.

NEXT ROW: (RS) Knit to end of row.

SHORT-ROW 7: (WS) K20 (24, 27, 30, 34, 37), wrap next st, turn work.

NEXT ROW: (RS) Knit to end of row.

NEXT ROW: (WS) Knit to end of row.

SHORT-ROW 8: (RS) K16 (20, 22, 24, 27, 30), wrap next st, turn work.

NEXT ROW: (WS) Knit to end of row.

NEXT ROW: (RS) Knit to end of row.

SHORT-ROW 9: (WS) K16 (20, 22, 24, 27, 30), wrap next st, turn work.

NEXT ROW: (RS) Knit to end of row.

NEXT ROW: (WS) Knit to end of row.

SHORT-ROW 10: (RS) K12 (15, 17, 18, 20, 23), wrap next st, turn work.

NEXT ROW: (WS) Knit to end of row.

NEXT ROW: (RS) Knit to end of row.

SHORT-ROW 11: (WS) K12 (15, 17, 18, 20, 23), wrap next st, turn work.

NEXT ROW: (RS) Knit to end of row.

NEXT ROW: (WS) Knit to end of row.

Blackcomb Cowl

DESIGNED BY HOLLI YEOH

This luscious, oversized cowl is deeply textured, thanks to springy double garter stitch. It's constructed by first working a rectangle with long rows, then picking up stitches along one selvedge edge. The rest of the cowl is worked perpendicular to the original rows. Wear it draped once around the shoulders as a voluminous wrap or doubled as a cozy neckwarmer.

FINISHED SIZE

58" (147 cm) in circumference and 14" (35.5 cm) tall.

YARN

Chunky weight (#5 Bulky).
Shown here: Miss Babs K2 (100% merino wool; 240 yd [219 m]/7¼ oz [204 g]): Blackwatch, 3 skeins.

NEEDLES

Size U.S. 10½ (7 mm): straight.
Adjust needle size if necessary to obtain the correct gauge.

NOTIONS

Spare smaller needle for three-needle BO; tapestry needle.

GAUGE

13½ sts and 12 rows = 4" (10 cm) in double garter st, blocked.

Notes

* This cowl is knit in two stages. After the first panel is complete, stitches are picked up along one edge for the second panel.

* This cowl begins with a double-wrap long-tail CO (see Stitch Guide), which is very similar to the standard long-tail cast-on (see Glossary) and requires a familiarity with this method. The yarn is wrapped twice around the needle, creating a double wrap for each stitch.

* The edges are joined by working modified three-needle bind-off (see Glossary) with picked up selvedge stitches on the back needle. Alternately, simply bind off and then seam the two ends together.

STITCH GUIDE

Double-Wrap Long-Tail CO

Beg with a slipknot on the right needle. Set your yarn and hand position as for the long-tail CO (see Glossary). *Come up through loop on thumb as usual, catch strand around index finger and wrap yarn twice around the needle, go back down through loop on thumb and complete stitch as for long-tail CO; rep from * to desired number of sts. The initial slipknot counts as 1 st and each double-wrapped st counts as 1 st.

Double Garter St (odd number of sts)

ROW 1: K1 into first wrap of double-wrap st, leaving 2nd wrap on left needle, *k2tog (rem wrap of first st with first wrap of next st), wrapping yarn twice around right needle; rep from * to end of row.

Rep Row 1 every row for Double Garter St patt.

COWL

Work First Panel

Using the double-wrap long-tail method (see Stitch Guide), CO 95 sts.

Beg with a WS row, work Double Garter St (see Stitch Guide) until piece measures 14" (35.5 cm) from CO, ending with a RS row.

Loosely BO as foll:

BO ROW: (WS) K1, *K2tog (rem wrap of previous st with first wrap of next st), pass first st on right needle over 2nd st and off needle; rep from * to end.

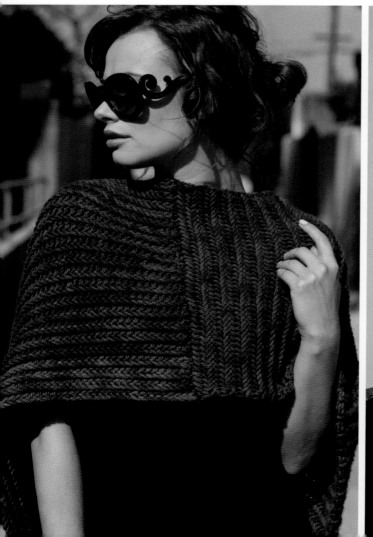
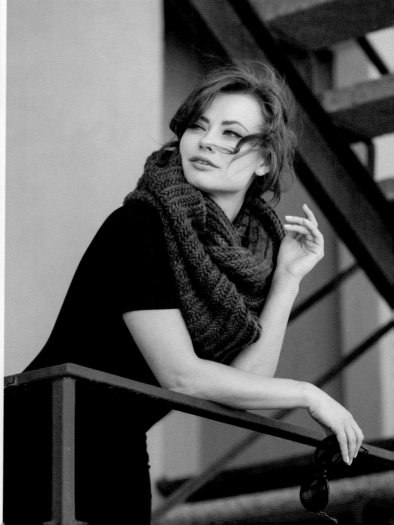

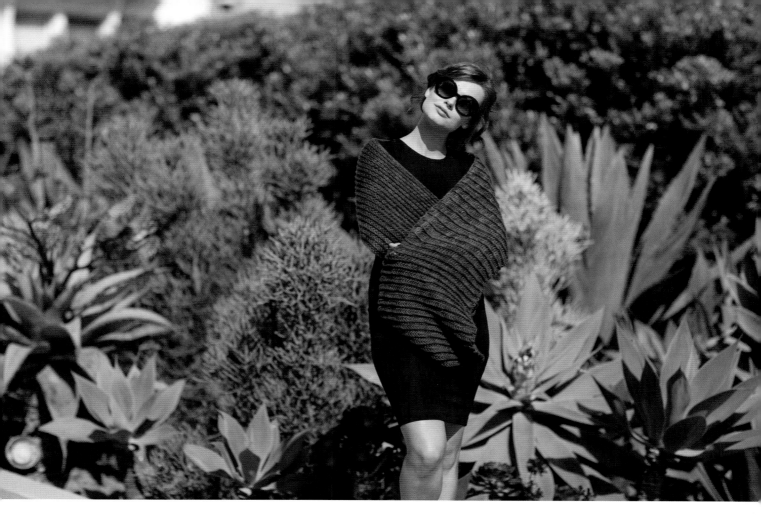

Work Second Panel

With first half, RS facing, beg in lower right corner, pick up and knit 1 st, then, wrapping yarn twice around the needle, pick up and knit 46 sts along right edge—47 sts; 1 single st, 46 double-wrap sts.

Work double garter st until cowl measures 58" (147 cm) from edge of first half, ending with a RS row.

Join Ends

With spare needle, WS of first half facing, and entering st from back to front, pick up but do not knit 47 sts evenly along left edge.

With RS tog and second half in front, join pieces as foll:

JOINING ROW: (WS) K2tog (first wrap of st on front needle with first st on back needle), *k3tog (rem wrap of previous st and first wrap of next st on front needle with next st on back needle), pass first st on right needle over 2nd st and off needle; rep from * to end.

FINISHING

Block lightly to measurements. Weave in ends.

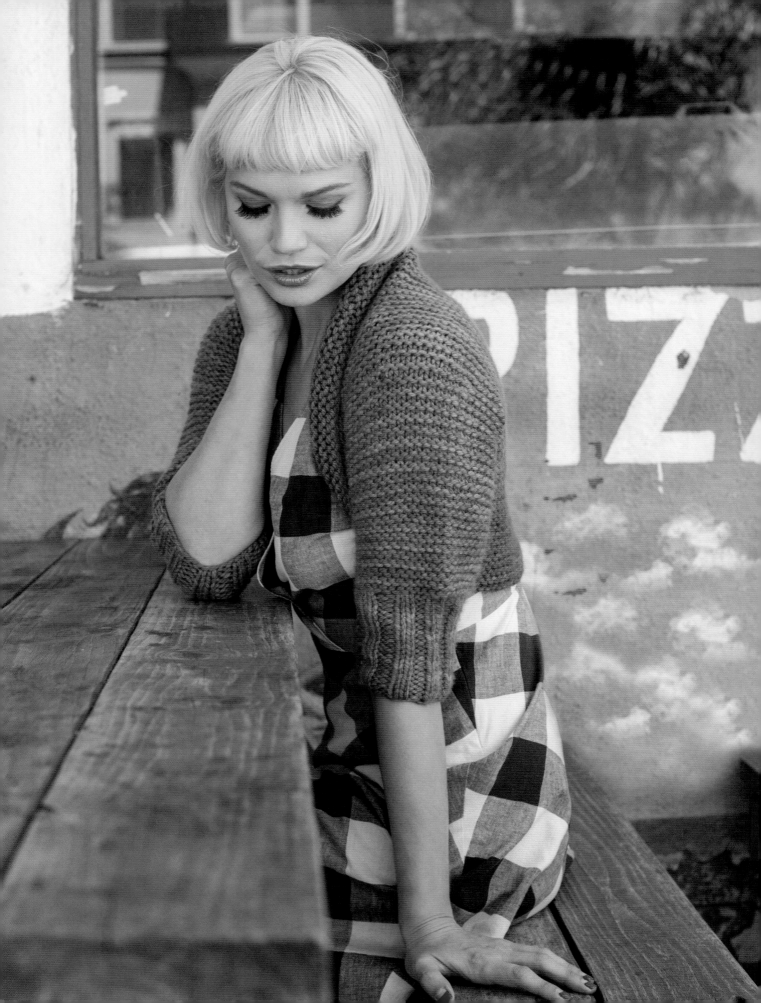

Autumn Evening Shrug

DESIGNED BY MELISSA LABARRE

This cozy little shrug is a great piece for transitional weather. Covering just the shoulders and with half length sleeves, it's perfect on a cool night that doesn't call for a whole sweater. Knit side-to-side in a chunky yarn, it's a fun and quick way to get ready for fall.

FINISHED SIZE

16¼ (18¼, 20, 21¾, 23¾)" (41.5 [46.5, 51, 55, 60.5] cm) wide across back measuring from center of underarm to center of underarm.

Shrug shown measures 18¼" (46.5 cm).

YARN

Chunky weight (#5 Bulky).
Shown here: Malabrigo Chunky (100% wool; 104 yd [95 m]/3½ oz [100 g]): #74 Polvoriento: 4 (5, 5, 6, 6) skeins.

NEEDLES

Size U.S. 11 (8 mm): 29" (80 cm) circular (cir) and set of 4 or 5 double-pointed (dpn).
Adjust needle size if necessary to obtain the correct gauge.

NOTIONS

Markers (m); tapestry needle.

GAUGE

12 sts and 22 rows = 4" (10 cm) in garter st, blocked.

Note

* This shrug is worked cuff to cuff, first working garter stitch in the round for the first sleeve, then knitting back and forth across the back, and then returning to working in the round for the second sleeve. Stitches are picked up around the body to lengthen the back and create the rolled collar.

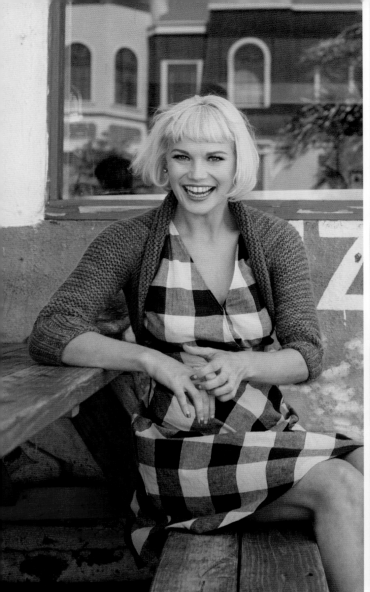

LEFT SLEEVE

With dpn, and using the long-tail method (see Glossary), CO 32 sts. Place marker (pm) and join for working in the rnd.

Cuff

NEXT RND: *K2, p2; rep from * to end of rnd.

Work in k2, p2 rib as established until cuff measures 5" (12.5 cm) from CO.

Shape Sleeve

Sizes 18¼ (20, 21¾, 23¾)" only
INC RND: *K7, knit 1 into front and back, (k1f&b see Glossary); rep from * to end of rnd—36 sts.

Purl 1 rnd.

Sizes 16¼ (18¼)" only
Work 44 (42) rnds in garter st, ending with a purl rnd. Piece should measure 13" (33 cm) from CO.

Sizes 20 (21¾, 23¾)" only
Work 13 (13, 7) rnds in garter st (knit 1 rnd; purl 1 rnd), ending with a knit rnd.

NEXT RND: *P12, pm; rep from * once more.

INC RND: *Knit to 1 st before m, k1f&b; rep from * to end of rnd—3 sts inc'd.

Rep inc rnd every 0 (16th, 10th) rnd 0 (1, 2) more time(s), removing 2 inc m on last rep—39 (42, 45) sts.

Work 27 (11, 13) rnds even, ending with a purl rnd. Piece should measure 13" (33 cm) from CO.

BACK

Change to cir needle. Beg working back and forth in rows.

INC ROW: (RS) *K7 (8, 8, 9, 10), k1f&b; rep from * 3 more times, k0 (0, 3, 2, 1)—36 (40, 43, 46, 49) sts.

Turn work and work 90 (100, 110, 120, 130) rows in garter st (knit every row). Back should

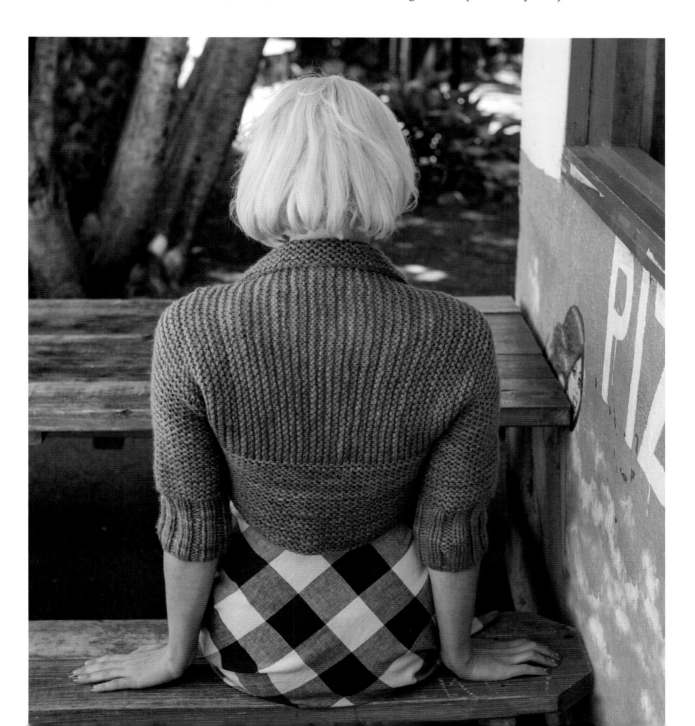

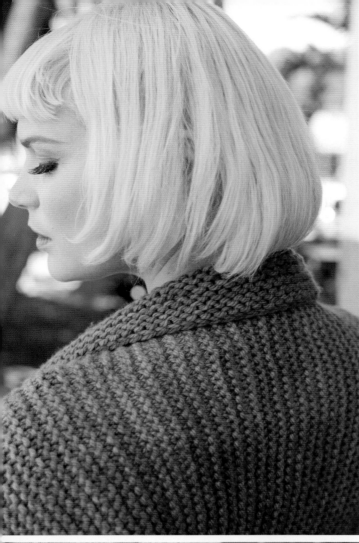

measure 16¼ (18¼, 20, 21¾, 23¾)" (41.5 [46.5, 51, 55, 60.5] cm) from beg of opening, ending with a WS row.

Change to dpn.

DEC RND: (RS) *K7 (8, 8, 9, 10), k2tog; rep from * 3 more times, k0 (0, 3, 2, 1), pm and join for working in the rnd—32 (36, 39, 42, 45) sts rem.

RIGHT SLEEVE

Beg with a purl rnd, work 44 (42, 26, 10, 12) rnds in garter st, ending with a knit rnd.

Shape Sleeves

Sizes 20 (21¾, 23¾)" only
NEXT RND: P13 (14, 15), pm; rep from * once more.

DEC RND: Knit to 2 sts before m, k2tog; rep from * to end of rnd—3 sts dec'd.

Rep dec rnd every 0 (16th, 10th) rnd 0 (1, 2) more time(s), removing 2 dec m on last rep—36 sts rem.

Work 15 (15, 9) rnds in garter st, ending with a purl rnd.

Sizes 18¼ (20, 21¾, 23¾)" only
DEC RND: *K7, k2tog, rep from * to end of rnd—32 sts rem.

Cuff
Work in k2, p2 rib for 5" (12.5 cm).

BO all sts in patt.

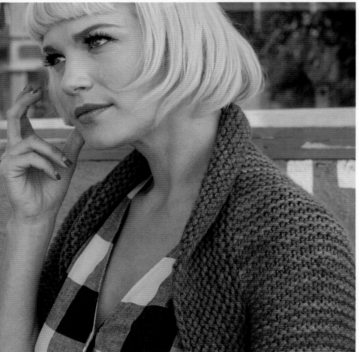

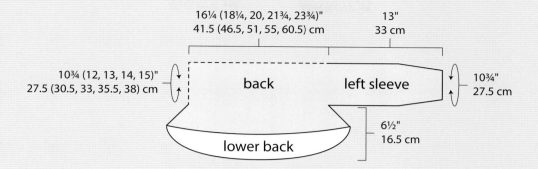

16¼ (18¼, 20, 21¾, 23¾)"
41.5 (46.5, 51, 55, 60.5) cm

13"
33 cm

10¾ (12, 13, 14, 15)"
27.5 (30.5, 33, 35.5, 38) cm

back

left sleeve

10¾"
27.5 cm

6½"
16.5 cm

lower back

LOWER BACK

With cir needle, pick up and knit 45 (50, 55, 60, 65) sts (1 st in each garter ridge) along the bottom long edge of the opening. Do not join.

Knit 5 rows.

DEC ROW: (RS) K1, ssk, knit to last 3 sts, k2tog, k1—2 sts dec'd.

Rep dec row every 4th row 3 more times—37 (42, 47, 52, 57) sts rem.

Knit 1 row

Rolled Collar
Do not turn. With RS facing and beg after last st worked, pick up and knit 9 sts along left edge of lower back panel, 45 (50, 55, 60, 65) sts along opposite long edge of opening, 9 sts along right edge of lower back panel—100 (110, 120, 130, 140) sts. Pm and join for working in the rnd.

Beg with a purl rnd, work 3 rnds in garter st (purl 1 rnd, knit 1 rnd).

INC RND: *K4, k1f&b, rep from * to end of rnd—120 (132, 144, 156, 168) sts.

Work 7 rnds, ending with a purl rnd.

INC RND : *K5, k1f&b, rep from * to end of rnd—140 (154, 168, 182, 196) sts.

Work 6 rnds, ending with a knit rnd.

BO all sts pwise.

FINISHING

Weave in ends. Wet block.

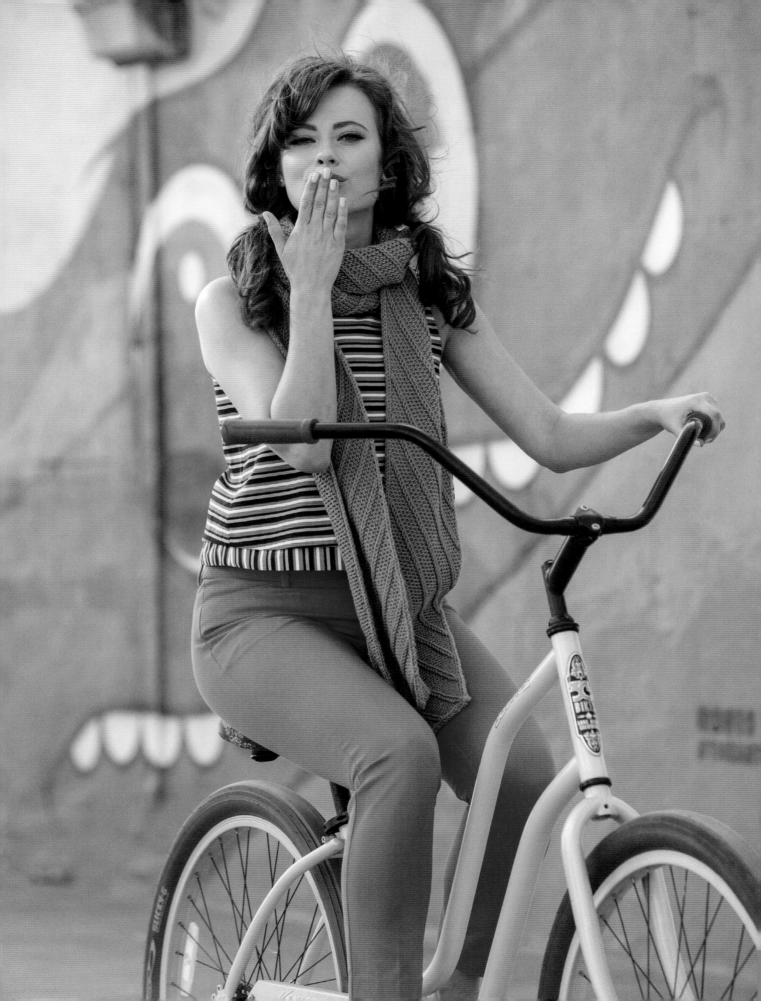

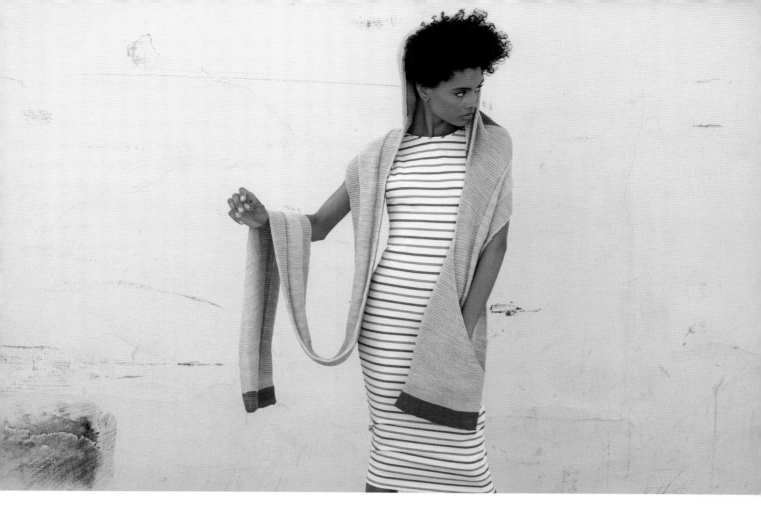

NEXT ROW: Knit to 1 st before m, sl 1 pwise wyf, remove m and transfer rem 50 sts to holder for left side—120 sts rem.

NEXT ROW: K1, purl to last st, sl 1 pwise wyf.

Break MC, join CC.

DEC ROW: (RS) K2, ssk, knit to last 4 sts, k2tog, k1, sl 1 pwise wyf—2 sts dec'd.

NEXT ROW: K1, purl to last 3 sts, p1 through the back loop (p1tbl, see Glossary), p1, sl 1 pwise wyf.

Rep last 2 rows 2 more times—114 sts rem.

Break CC, join MC, rep last 2 rows once more—112 sts rem.

Using the elastic BO method (see Glossary), BO all sts, leaving a 1 yd (1 m) tail.

LEFT SIDE OF SCARF

With RS facing, return 50 left side sts to needle and rejoin MC—50 sts.

NEXT ROW: (RS) Knit to m, sl m, p1, k16, p1, sl m, knit to last st, sl 1 pwise wyf.

NEXT ROW: (WS) Knit to m, sl m, k1, p16, k1, sl m, knit to last st, sl 1 pwise wyf.

Rep last 2 rows 15 more times, ending with a WS row.

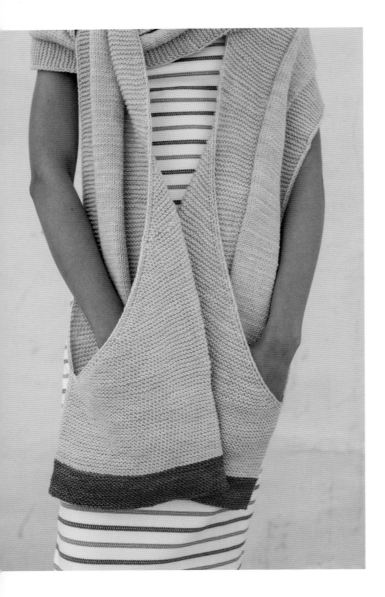

NEXT RND: Knit to m, sl m, k1, p16, k1, sl m, knit to end of rnd.

NEXT RND: Purl to m, sl m, k1, p16, k1, sl m, purl to end of rnd.

Rep last 2 rnds 23 more times.

Pocket Contrast

Break MC, join to CC.

Work garter st in the rnd (knit 1 rnd; purl 1 rnd) for 24 rnds.

Break yarn, leaving a 22" (56 cm) tail. With wrong side of pocket facing, use the three needle BO (see Glossary) to close pocket.

RIGHT SIDE OF SCARF

With WS facing, return 50 right side sts to needle and rejoin MC—50 sts.

Cont in patt, work 380 rows, ending with a RS row. Piece should measure 45" (114.5 cm) from hood.

Shape Diagonal

INC ROW: (WS) K1, k1f&b, work in patt to end of row—1 st inc'd.

Rep inc row every WS row 49 more times, knitting last st of row on last rep—100 sts.

Pocket

Fold diagonal edge over RS, pm, and join for working in the rnd. Beg with a purl rnd, complete right pocket and pocket contrast as for left pocket.

Shape Diagonal

INC ROW: (RS) K1, knit 1 into front and back (k1f&b, see Glossary), work in patt to end of row—1 st inc'd.

Rep inc row every RS row 49 more times—100 sts.

Work 1 WS row.

Pocket

Fold diagonal edge over RS, pm, and join for working in the rnd.

FINISHING

Weave in ends and block. Block hood facing flat and fold into position. Using tail, invisibly sew facing to interior of hood, stitching behind BO edge and through a garter st ridge.

Tassel

Using CC, make a 2½" (6.5 cm) tassel (see Glossary), leaving a long tail when tying the top loop. Incorporate shorter tail from tie into tassel. Using a crochet hook and the long tail, pull up a loop from under the top tie and chain 4 (see Glossary). Insert hook through the garter ridge tip of hood from original CO and pull working yarn all the way through all loops. Thread end and weave back through the chain tie to the top of the tassel, then incorporate the remainder of the tail into the tassel length. Trim.

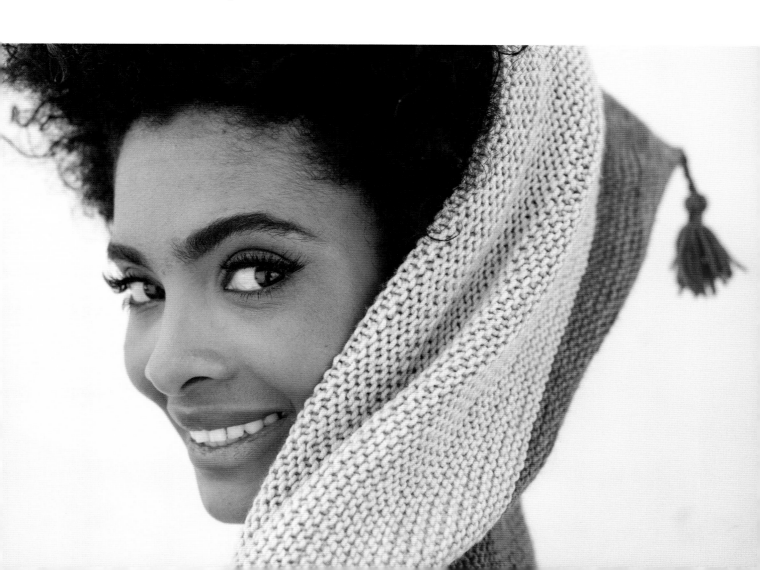

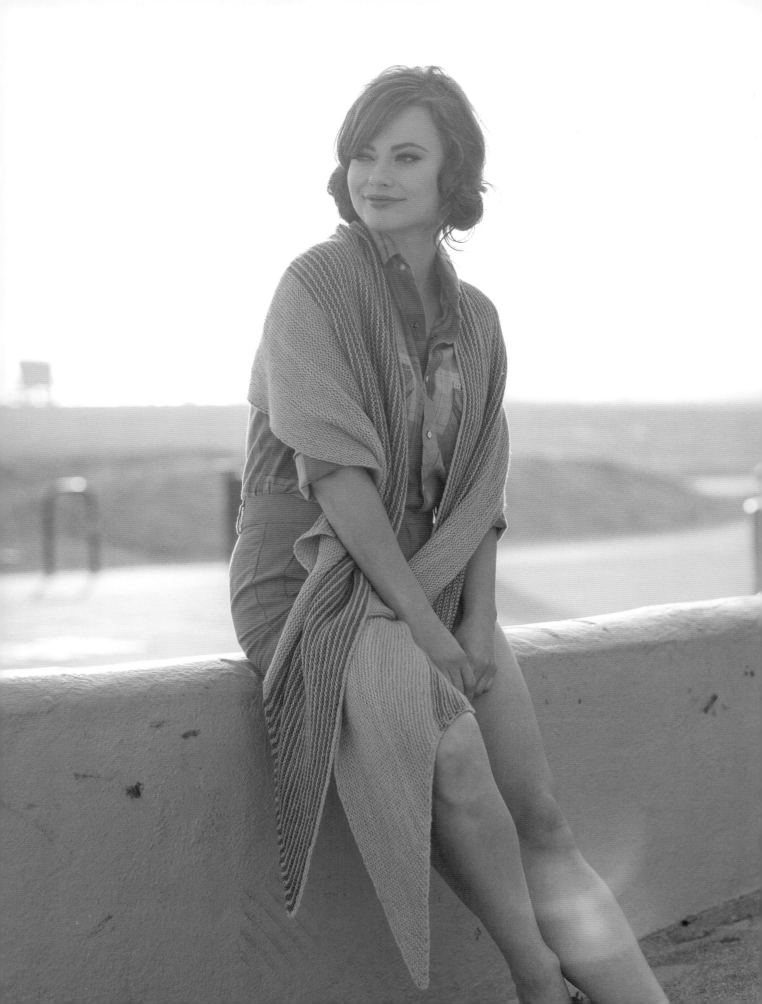

Venice Beach Wrap

DESIGNED BY ANNIE ROWDEN

This is a shawl for all occasions—a go-to accessory on cooler days and a show stopper to complement your favorite little black dress. It's extra long to allow you to wrap it any which way you choose, but not bulky, thanks to the silk-merino blend yarn. No-fuss striping against color blocking makes an attractive, modern effect.

FINISHED SIZE

88" (223.5 cm) wide and 18" (38 cm) long.

YARN

Sportweight (#2 Fine).

Shown here: Swans Island Natural Colors Merino/Silk Sport (50% fine merino wool, 50% tussah silk; 175 yd [160 m]/1¾ oz [50 g]): Fog (MC), 5 skeins; Lapis (CC), 2 skeins.

NEEDLES

Size U.S. 5 (3.75 mm): straight.

Adjust needle size if necessary to obtain the correct gauge.

NOTIONS

Removable marker (optional); tapestry needle.

GAUGE

15 sts and 38 rows = 4" (10 cm) in garter st, blocked.

Note

* It may be helpful to mark the right side of the work with a removable stitch marker or safety pin.

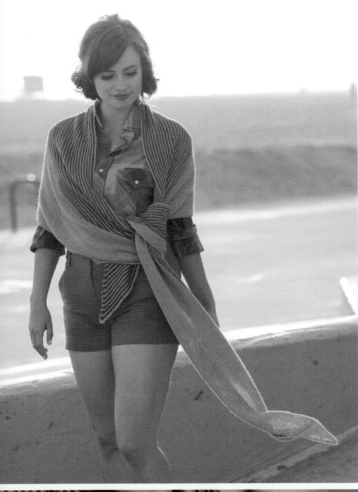

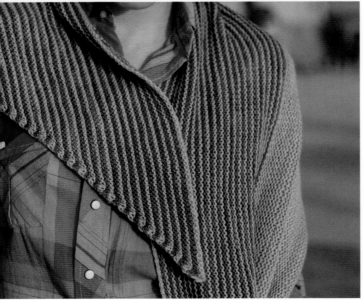

SHAWL

With MC and using the Old Norwegian CO method (see Glossary), CO 330 sts.

ROW 1: (RS) K2, M1L (see Glossary), knit to last 3 sts, k2tog, k1.

ROW 2: (WS) Knit.

Rep last 2 rows 43 more times.

Join CC and begin striping pattern as foll:

ROW 1: (RS) With CC, k2, M1L, knit to last 3 sts, k2tog, k1.

ROW 2: (WS) Knit.

ROW 3: With MC, k2, M1L, knit to last 3 sts, k2tog, k1.

ROW 4: Knit.

Rep last 4 rows 21 more times.

Using the Icelandic BO method (see Glossary), BO all sts.

FINISHING

Weave in ends and block.

ABBREVIATIONS

beg(s)	begin(s); beginning
BO	bind off
CC	contrast color
ch	chain (crochet)
cir	circular
cm	centimeter(s)
cn	cable needle
CO	cast on
cont	continue(s); continuing
dec(s)('d)	decrease(s); decreasing; decreased
dpn	double-pointed needles
est	established
foll	follow(s); following
g	gram(s)
inc(s)('d)	increase(s); increasing; increase(d)
k	knit
k1f&b	knit one stitch into front and back of same stitch (increase)
k1tbl	knit one stitch through the back loop
k2tog	knit two stitches together (decrease)
k3tog	knit three stitches together (decrease)
kwise	knitwise, as if to knit
LH	left hand
LLI	left lifted increase
m	marker

mm	millimeter(s)
M1	make one stitch (increase)
M1L	make one stitch left slant (increase)
M1P	make one stitch purlwise (increase)
M1R	make one stitch right slant (increase)
oz	ounce
p	purl
p1f&b	purl one stitch into front and back of same stitch (increase)
p1tbl	purl one stitch through the back loop
p2tog	purl two stitches together (decrease)
p3tog	purl three stitches together (decrease)
patt(s)	pattern(s)
pm	place marker
pwise	purlwise, as if to purl
rem	remain(s); remaining
rep	repeat(s); repeating
RLI	right lifted increase
rnd(s)	round(s)
RS	right side
s2kp2	slip two stitches together knitwise, knit one, pass slipped stitches over (decrease)
sc	single crochet

sk2p	slip one stitch knitwise, knit two stitches together, pass slipped stitch over (decrease)
sl	slip
sl st	slip stitch (slip one stitch purlwise unless otherwise indicated)
ssk	slip one stitch knitwise, slip one stitch knitwise, knit two slipped stitches together through the back loop (decrease)
sssk	slip, slip, slip, knit (decrease)
st(s)	stitch(es)
St st	stockinette stitch
tbl	through the back loop

tog	together
w&t	wrap and turn
WS	wrong side
wyb	with yarn in back
wyf	with yarn in front
yd	yard(s)
yo	yarnover
*****	repeat starting point
******	repeat all instructions between asterisks
()	alternate measurements and/or instructions
[]	work instructions as a group a specified number of times

GLOSSARY

BIND-OFFS

Elastic Bind-Off

K1, *yo, k1, pass the first knit stitch and yo over second knit stitch; rep from * to end.

Icelandic Bind-Off

K1, *slip the next stitch from the right needle to the left needle purlwise (Figure 1). Insert the right needle purlwise into the first stitch on the left needle, then knitwise into the second stitch to catch the front loop (Figure 2). Draw the front loop of the second stitch through the first stitch and knit it (Figure 3). Drop both stitches from the left needle (Figure 4). Repeat from *.

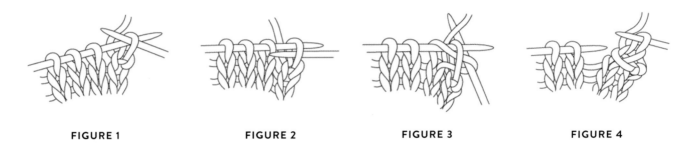

FIGURE 1 FIGURE 2 FIGURE 3 FIGURE 4

Standard Bind-Off

Knit the first stitch, *knit the next stitch (two stitches on the right needle), insert the left needle tip into the first stitch on the right needle (Figure 1) and lift this stitch up and over the second stitch (Figure 2) and off the needle (Figure 3). Repeat from * for the desired number of stitches.

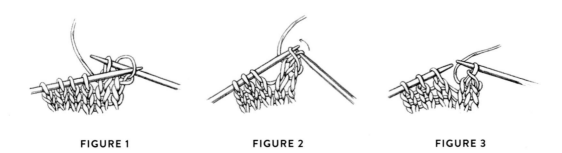

FIGURE 1 FIGURE 2 FIGURE 3

Three-Needle Bind-Off

Place the stitches to be joined onto two separate needles and hold the needles parallel so that the right sides of knitting face together. Insert a third needle into the first stitch on each of the two needles (Figure 1) and knit them together as one stitch (Figure 2), *knit the next stitch on each needle the same way, then use the left needle tip to lift the first stitch over the second and off the needle (Figure 3). Repeat from * until no stitches remain on the first two needles. Break the yarn and pull the tail through the last stitch to secure.

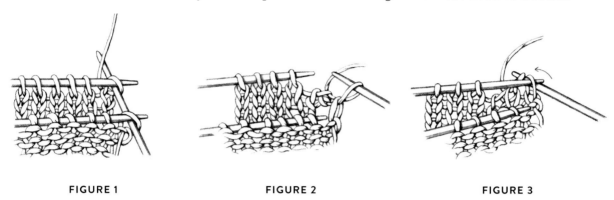

FIGURE 1 FIGURE 2 FIGURE 3

BUTTONHOLES

2 (3, 4, 5) Stitch One-Row Buttonhole

Work to where you want the buttonhole to begin, bring yarn to front, slip one stitch purlwise, bring yarn to back (Figure 1). *Slip one stitch purlwise, pass first slipped stitch over second; repeat from * one (two, three, four) more time(s). Place the last stitch back on the left needle (Figure 2), turn.

Cast on 3 (4, 5, 6) stitches as follows: *Insert the right needle between the first and second stitches on the left needle, draw up a loop, and place it on the left needle (Figure 3); repeat from * two (three, four, five) more times, turn. Bring yarn to back, slip the first stitch on the left needle onto the right needle and pass the last cast-on stitch over it (Figure 4), work to end of row.

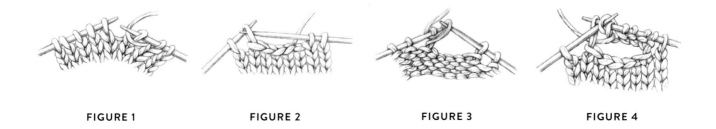

FIGURE 1 FIGURE 2 FIGURE 3 FIGURE 4

Backward-Loop Cast-On

*Loop working yarn as shown and place it on the needle backward with right leg of loop in back of the needle (Figure 1). Repeat from *.

FIGURE 1

Cable Cast-On

If there are no stitches on the needles, make a slipknot of working yarn and place it on the needle, then use the knitted cast-on method (see below) to cast on one more stitch—two stitches on the needle. Hold the needle with working yarn in your left hand. *Insert the right needle between the first two stitches on the left needle (Figure 1), wrap yarn around needle as if to knit, draw yarn through (Figure 2), and place the new loop on the left needle (Figure 3) to form a new stitch. Repeat from * for the desired number of stitches, always working between the two stitches closest to the tip of the left needle.

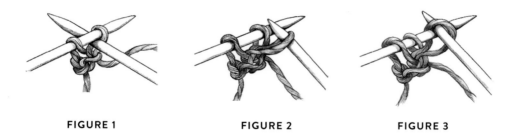

FIGURE 1 **FIGURE 2** **FIGURE 3**

Chain-Edge Cast-On

This cast-on method is worked with a crochet hook and can be used in one of two ways: as a decorative cast-on that forms a tidy chain and perfectly matches the bind-off row or as a provisional cast-on. For the decorative cast-on, use the working yarn for the crochet chain. For a provisional cast-on, use waste yarn for the chain and then knit a plain row with the working yarn (the provisional cast-on is not complete until there is a row of working yarn stitches on the needle).

Place a slipknot on a crochet hook. Hold the knitting needle and yarn in your left hand and hook in your right hand, with yarn under the needle. Place the hook over the needle, wrap yarn around the hook, and pull the loop through the loop on the hook (Figure 1). *Bring yarn to back under the needle, wrap yarn around the hook, and pull it through the loop on the hook (Figure 2). Repeat from *until there is one fewer stitch than the desired number on the needle. Slip loop from hook to needle for the last stitch.

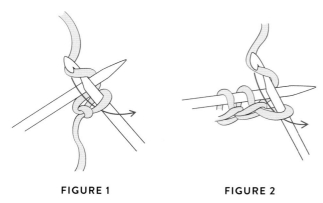

FIGURE 1 FIGURE 2

Judy's Magic Cast-On

Hold two needles parallel in your right hand, one on top of the other and needle points facing to the left. Leaving a tail long enough to cast on the required number of stitches, drape the yarn over the top needle so the tail is in the front and the ball yarn is in the back (Figure 1). Cross the yarns so the tail is in the back and the ball yarn is in the front, then place the thumb and index finger of your left hand between the two strands so that the tail is over your index finger and the ball yarn is over your thumb (Figure 2). This forms the first stitch on the top needle.

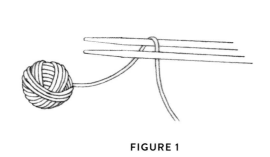

FIGURE 1

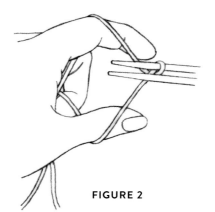

FIGURE 2

*Pivoting both needles together, bring the bottom needle over the top of the finger yarn, then bring the finger yarn up from below the bottom needle, over the top of this bottom needle, then to the back between the two needles (Figure 3). This forms the first stitch on the bottom needle.

Point the needles downward, bring the bottom needle past the thumb yarn, then bring the thumb yarn between the two needles to the front then over the top needle (Figure 4). There are now two stitches on the top needle.

Repeat from * until you have the desired number of stitches on each needle. Both needles should have the same number of stitches (Figure 5).

Remove both yarn ends from your left hand, rotate the needles like the hands of a clock so that the bottom needle is now on top and both strands of yarn are at the needle tip (Figure 6).

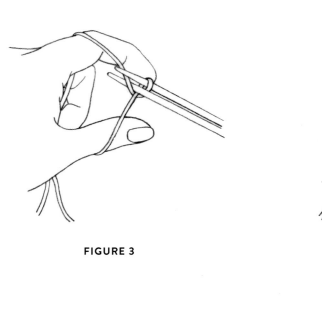

FIGURE 3

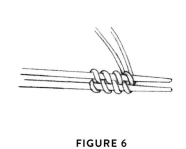

FIGURE 4

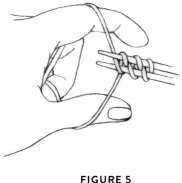

FIGURE 5

FIGURE 6

GRAFTING

Kitchener Stitch

Arrange stitches on two needles so that there is the same number of stitches on each needle. Hold the needles parallel to each other with wrong sides of the knitting together. Allowing about ½" (1.3 cm) per stitch to be grafted, thread matching yarn onto a tapestry needle. Work from right to left as follows:

STEP 1. Bring the tapestry needle through the first stitch on the front needle as if to purl and leave that stitch on the needle (Figure 1).

STEP 2. Bring the tapestry needle through the first stitch on the back needle as if to knit and leave that stitch on the needle (Figure 2).

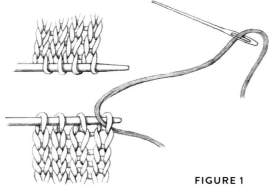

FIGURE 1

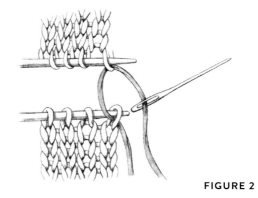

FIGURE 2

STEP 3. Bring the tapestry needle through the first front stitch as if to knit and slip that stitch off the needle, then bring the tapestry needle through the next front stitch as if to purl and leave that stitch on the needle (Figure 3).

STEP 4. Bring the tapestry needle through the first back stitch as if to purl and slip that stitch off the needle, then bring the tapestry needle through the next back stitch as if to knit and leave that stitch on the needle (Figure 4).

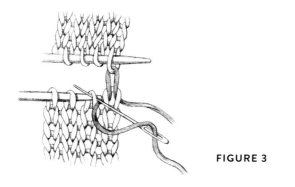

FIGURE 3

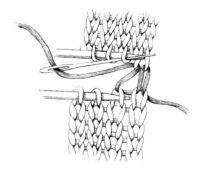

FIGURE 4

Repeat Steps 3 and 4 until one stitch remains on each needle, adjusting the tension to match the rest of the knitting as you go. To finish, bring the tapestry needle through the front stitch as if to knit and slip that stitch off the needle, then bring the tapestry needle through the back stitch as if to purl and slip that stitch off the needle.

INCREASES

Knit 1 into Front and Back (k1f&b)

Knit into a stitch but leave it on the left needle (Figure 1), then knit through the back loop of the same stitch (Figure 2) and slip the original stitch off the needle (Figure 3).

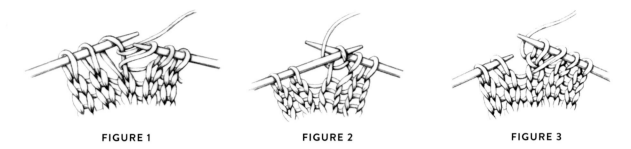

FIGURE 1 FIGURE 2 FIGURE 3

LIFTED INCREASES

Right Lifted Increas (RLI)

Knit into the back of the stitch (in the purl bump) in the row directly below the stitch on the left needle (Figure 1).

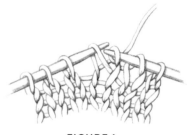

FIGURE 1

Left Lifted Increase (LLI)

Insert the left needle from front to back into the stitch below the stitch just knitted (Figure 1). Knit this stitch (Figure 2).

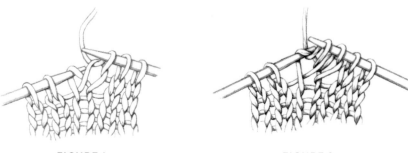

FIGURE 1 FIGURE 2

MAKE ONE (M1) INCREASES

Left Slant (M1L) and Standard M1

Note: Use the left slant if no direction of slant is specified.

With the left needle tip, lift the strand between the last knitted stitch and the first stitch on the left needle from front to back (Figure 1), then knit the lifted loop through the back (Figure 2).

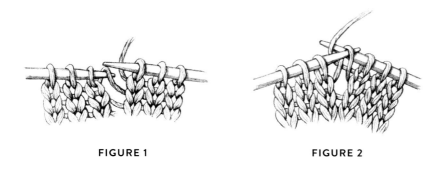

FIGURE 1 **FIGURE 2**

Right Slant (M1R)

With the left needle tip, lift the strand between the needles from back to front (Figure 1). Knit the lifted loop through the front (Figure 2).

For the purl versions (M1P, M1LP, and M1RP), work as above, purling the lifted loop.

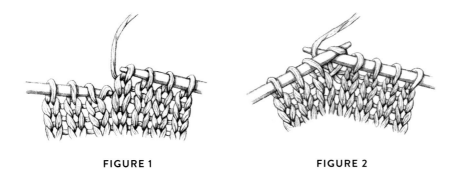

FIGURE 1 **FIGURE 2**

PICK UP AND KNIT

Along Cast-On or Bind-Off Edge

With right side facing and working from right to left, insert the tip of the needle into the center of the stitch below the cast-on or bind-off edge (Figure 1), wrap yarn around needle, and pull through a loop (Figure 2). Pick up one stitch for every existing stitch.

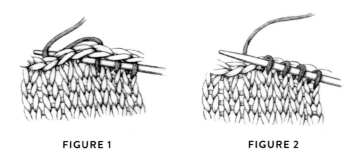

FIGURE 1 FIGURE 2

Along Shaped Edge

With right side facing and working from right to left, insert the tip of the needle between the last and second-to-last stitches, wrap yarn around needle, and pull through a loop (Figure 1). Pick up and knit three stitches for every four rows, adjusting as necessary so that the picked-up edge lies flat.

FIGURE 1

MATTRESS STITCH

Mattress Stitch on Stockinette Fabric

Place the pieces to be seamed on a table, right sides facing up. Begin at the lower edge and work upward as follows: Insert threaded needle under one bar between the two edge stitches on one piece then under the corresponding bar plus the bar above it on the other piece (Figure 1). *Pick up the next two bars on the first piece (Figure 2), then the next two bars on the other (Figure 3). Repeat from *, ending by picking up the last bar or pair of bars on the first piece.

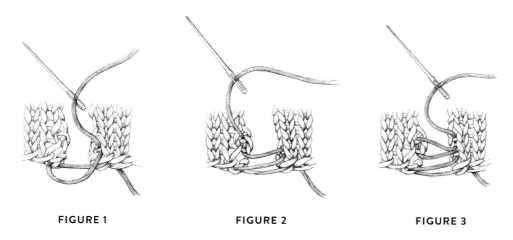

FIGURE 1 FIGURE 2 FIGURE 3

Mattress Stitch on Garter Fabric

Working with the right sides of the knitting facing, use the threaded tapestry needle to pick up the lower purl bar between the last two stitches on one piece, then the upper purl bar from the stitch next to the edge stitch on the same row on the other piece (Figure 1). To reduce bulk, work into the upper bar from the edge stitch (Figure 2) instead of the second-to-last stitch; keep in mind that the seam will be less firm.

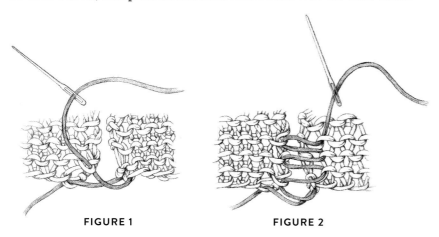

FIGURE 1 FIGURE 2

Short-Rows

Note: When working short-rows in garter stitch, it is not necessary to work the wraps together with the stitches they wrap because the wraps will be hidden in the garter ridges.

Knit Side

Work to the turning point, slip the next stitch purlwise (Figure 1), bring the yarn to the front, then slip the same stitch back to the left needle (Figure 2), turn the work around and bring the yarn in position for the next stitch—one stitch has been wrapped, and the yarn is correctly positioned to work the next stitch.

When you come to a wrapped stitch on a subsequent row, hide the wrap (see note above) by working it together with the wrapped stitch as follows: Insert the right needle tip under the wrap (from the front if wrapped stitch is a knit stitch; from the back if wrapped stitch is a purl stitch; Figure 3), then into the stitch on the needle and work the stitch and its wrap together as a single stitch.

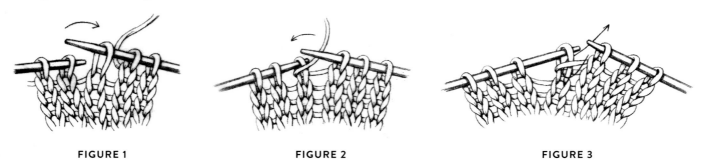

FIGURE 1 FIGURE 2 FIGURE 3

Purl Side

Work to the turning point, slip the next stitch purlwise to the right needle, bring the yarn to the back of the work (Figure 1), return the slipped stitch to the left needle, bring the yarn to the front between the needles (Figure 2), and turn the work so that the knit side is facing— one stitch has been wrapped and the yarn is correctly positioned to knit the next stitch.

To hide the wrap (see note above) on a subsequent purl row, work to the wrapped stitch, use the tip of the right needle to pick up the wrap from the back, place it on the left needle (Figure 3), then purl it together with the wrapped stitch.

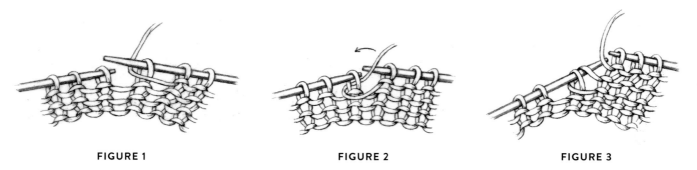

FIGURE 1 FIGURE 2 FIGURE 3

Tassel

Cut a piece of cardboard 4" (10 cm) wide by the desired length of the tassel plus 1" (2.5 cm). Wrap the yarn to the desired thickness around the cardboard. Cut a short length of yarn and tie it tightly around one end of the wrapped yarn (Figure 1). Cut yarn loops at the other end.

Cut another piece of yarn and wrap it tightly around the loops a short distance below the top knot to form the tassel neck. Knot securely, thread ends onto a tapestry needle, and pull to the center of tassel (Figure 2). Trim ends.

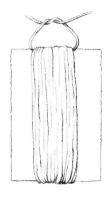

FIGURE 1

FIGURE 2

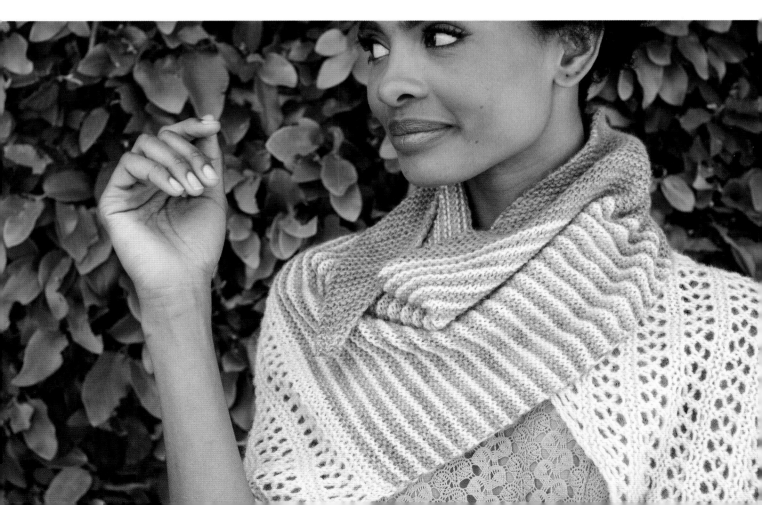

YARN SOURCES

Cascade
cascadeyarns.com

Debbie Bliss
Knitting Fever Inc.
PO Box 336
315 Bayview Avenue
Amityville, NY 11701
knittingfever.com

Dragonfly Fibers
4104 Howard Ave
Kensington, MD 20895
(301) 312-6883
dragonflyfibers.com

The Fibre Company
Kelbourne Woolens
2000 Manor Rd.
Conshohocken, PA 19428
484-368-3666
kelbournewoolens.com

Fiberstory
etsy.com/shop/fiberstory

Jill Draper Makes Stuff
etsy.com/shop/
jilldrapermakesstuff

Madelinetosh
madelinetosh.com
3430 Alemeda Street, STE #112
Fort Worth, TX 76126
(844) 309-4036

Malabrigo
(786) 427-1048
malabrigoyarn.com

Manos del Uruguay
Fairmount Fibers
PO Box 2082
Philadelphia, PA 19103
888-566-9970
fairmountfibers.com

Miss Babs
PO Box 78
Mountain City, TN 37683
(423) 727-0670
missbabs.com

Mountain Meadow Wool
22 Plains Dr.
Buffalo, WY 82834
(307) 684-5775
mountainmeadowwool.com

Plymouth Yarn
500 Lafayette St.
Bristol, PA 19007
(215) 788-0459
plymouthyarn.com

Rowan
Green Lane Mill
Holmfirth
West Yorkshire
England, HD9 2DX
+44 (0)1484 681881
knitrowan.com

Shibui
(503) 595-5898
shibuiknits.com

Stitch Sprouts
(877) 781-2042
stitchsprouts.com

Swans Island
231 Atlantic Highway
 (US Route 1)
Northport, ME 04849
(888) 526-9526
swansislandcompany.com

SweetGeorgia Yarns Inc.
110-408 E. Kent Ave. So.
Vancouver, BC V5X 2X7
Canada
604-569-6811
sweetgeorgiayarns.com

Universal Yarn
5991 Caldwell Business Park
 Drive
Harrisburg, NC 28075
 (704) 789-9276
universalyarn.com

Wooly Wonka Fiber
woolywonkafiber.com

ABOUT THE DESIGNERS

TOBY ROXANE BARNA is an independent knitwear designer living and working in the Hudson Valley of upstate New York. She loves color, cats, and cupcakes. Look for her patterns on Ravelry, follow her on Instagram and Twitter (@tobyroxane), and find her on Facebook as Toby Roxane Designs.
ravelry.com/designers/toby-roxane-barna

SACHIKO BURGIN lives in Toronto, Canada, and works part-time at Romni Wools. Despite having a degree in jewelry and metalsmithing, these days she prefers to work with yarn.
ravelry.com/designers/sachiko-burgin

KIRI FITZGERALD-HILLIER lives in Brisbane, Australia, with her husband and two children. She's a knitwear designer and owns an online yarn shop, Yay for Yarn.
yayforyarn.com.au
ravelry.com/designers/kiri-fitzgerald-hillier

AMY GUNDERSON learned how to knit at age 30 while running a pizza shop in Iowa with her husband. She had to learn very quickly how to read her knitting, as pesky customers were always calling and interrupting her WIPs. A few years later, she took a job with Universal Yarn where she still works as creative director. Her designs have been featured in *Interweave Knits*, *Knitscene*, *Interweave Crochet*, *Knit.Purl*, *Vogue Knitting*, and many more publications. She has also authored two books, *Crocheted Mitts & Mittens* and *Knitted Mitts and Mittens*, both with Stackpole Books.
ravelry.com/designers/amy-gunderson

FATIMAH HINDS left her job as an environmental consultant to stay home with her kids. To keep herself entertained, she began custom knitting and, ultimately, writing patterns. Fatimah's designs have a little edge and not too much fuss. She's a tutor, mommy, and lover of small-batch gin.
ravelry.com/designers/fatimah-hinds

LYNNETTE "NETT" HULSE is an Australian fiber artist with a background in graphic and web design. Her personal design aesthetic combines practicality with whimsy, focusing on interesting and fun approaches to everyday needs. By day, Nett spends her time "talking nerd" to her husband, running after their two amazing daughters, and petting their two very fluffy cats. By night she continues doing those things, but also designs knitwear.
vintagenettles.net
ravelry.com/designers/nett-hulse

COURTNEY KELLEY is the co-owner of Kelbourne Woolens, distributors of the Fibre Company yarns. She graduated from the School of the Art Institute of Chicago in 2001 with a focus in fiber and material studies and immediately began working in a knitting shop while attempting to become an artist. After a brief foray into the world of fine art, she founded Kelbourne Woolens along with her business partner in 2008. She is now the current chair of the Yarn Group of The National Needlearts Association. Courtney lives in Philadelphia with her son, her partner, and his son. She enjoys knitting and cross-stitching while everyone else plays Minecraft.
kelbournewoolens.com
ravelry.com/designers/courtney-kelley

JESSIE KSANZNAK is the creator of Yarn Over New York Designs. She splits her knitting time between Harlem in New York City and Vancouver, British Columbia. Her vocation as a stage manager has taken her all over the world with circus, dance, and theater productions. She has designed patterns for Blue Moon Fiber Arts Rockin' Sock Club, the Knittin' Little blog, and *Knit Now*.
yarnovernewyork.wordpress.com
ravelry.com/designers/jessie-ksanznak

MELISSA LABARRE is a freelance knitwear designer and work-at-home mama. She is co-author of the books *Weekend Hats, New England Knits*, and *Weekend Wraps*, all from Interweave. Her designs have been published in *Knitscene* and *Vogue Knitting* as well as in design collections for Quince & Co, Classic Elite, Valley Yarns, Blue Sky Alpacas, Brooklyn Tweed, and other yarn companies. She lives in Massachusetts with her husband and two children.
knittingschooldropout.com
ravelry.com/designers/melissa-labarre

ANNE PODLESAK knits, spins, and designs in the mountains of northern New Mexico. She is the author of several self-published collections as well as *Free Spirit Knits* from Interweave. She is also the indie dyer behind Wooly Wonka Fiber.
woolywonkafiber.com
ravelry.com/designers/anne-podlesak

EMILY ROSS is a third-generation knitter who has been designing since 2009. When not knitting, charting, frogging, or reknitting, she can be found performing as an active-duty military musician. She and her husband live in Virginia, where they are raising a (hopefully) fourth-generation knitter.
knitterain.com
ravelry.com/designers/emily-ross

ANNIE ROWDEN is originally from England, but finding her home in Northern California, she's a dairy-goat farmer obsessed with domestic wool, herbs, and natural dyes. Annie loves to support and work with local fibers and is enamored by the palette of natural pigments. Ultimately, she strives to bring the knitter closer to the farms and pastures in which wool grows.
byannieclaire.com
ravelry.com/designers/annie-rowden

JENNIE SANTOPIETRO is a knit designer and blogger from Texas. She loves having coffee dates and knit nights with good friends and looks forward to the days when it won't take an entire pot of coffee to keep going until bedtime, but she wouldn't trade it for the world. Originally a French teacher, Jennie now spends her days indulging in knitting experiments and enjoying time with her beautiful children and her family's lovely homemade life.
alovelyhomemadelife.com
ravelry.com/designers/jennie-santopietro

COURTNEY SPAINHOWER is a stay-at-home mom, knitting instructor, and the lady behind Pink Brutus Knits. She recently authored her first book, *Family-Friendly Knits* by Interweave.
pinkbrutus.com
ravelry.com/designers/courtney-spainhower

KRISTEN TENDYKE designs classic sweaters with unique construction. She specializes in seamless knitting and always keeps Mother Nature in mind when making yarn choices. Kristen strives to provide patterns that are easy to follow, enjoyable, and engaging to make. She is the author of *Finish-Free Knits* and *No-Sew Knits*, both from Interweave.
kristentendyke.com
ravelry.com/designers/kristen-tendyke

MEGAN ELYSE NODECKER is a knitwear designer who has been publishing patterns for the past five years. She lives in the cloudy and wet Pacific Northwest, and the temperamental climate has fueled her love for all things cozy. She tries to knit as much as possible while being a full-time toddler wrangler.
pipandpin.ca
ravelry.com/designers/megan-nodecker

BECKY YANKOWSKI taught herself how to knit at the tender age of eight. She spent years working as a seamstress in the garment industry before jumping into freelance knitwear design. Becky lives in South Texas where knitting with cotton, hemp, and linen is essential.
ravelry.com/designers/rebecca-yankowski

HOLLI YEOH is a Vancouver knitwear designer who has been self-publishing knitting patterns and teaching knitting techniques for well over a decade. In 2014, Holli collaborated with SweetGeorgia Yarns to publish *Tempest*, a sophisticated collection of knitting patterns for women. Her designs appear regularly in books and magazines including *Vogue Knitting*, *Noro Magazine*, and several of the *60 Quick* series of books (Sixth&Spring Books) as well as the online magazines Knitty and Twist Collective.
holliyeoh.com.

HEATHER ZOPPETTI, author of *Unexpected Cables* and *Everyday Lace*, both from Interweave, lives and works in Lancaster, Pennsylvania, with her husband and yarn collection. She is the owner of Stitch Sprouts.
stitchsprouts.com
hzoppettidesigns.com

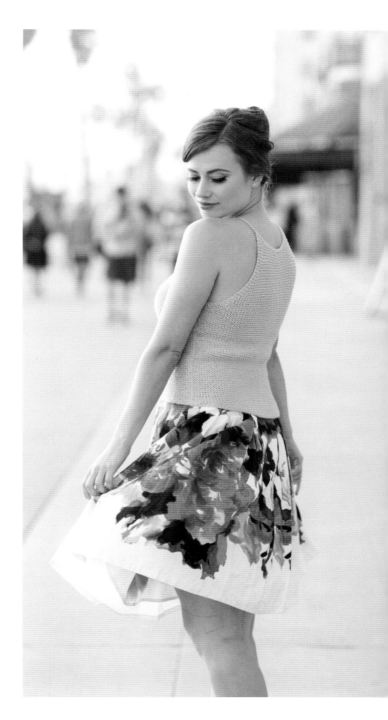